A Complete Guide to
Coaching and Teaching Netball

Ian Findley

First published by Busybird Publishing 2024

Copyright © 2024 Ian Findley

ISBN
Print: 978-1-923216-07-5
Ebook: 978-1-923216-08-2

This work is copyright. Apart from any use permitted under the *Copyright Act 1968*, no part of this publication may be reproduced, stored in a retrieval system or transmitted in any form or by any means, electronic, mechanical, photocopying, recording or otherwise, without the prior written permission of Ian Findley.

The information in this book is based on the author's experiences and opinions. The author and publisher disclaim responsibility for any adverse consequences, which may result from use of the information contained herein. Permission to use any external content has been sought by the author. Any breaches will be rectified in further editions of the book.

Cover Image: Ian Findley

Cover design: Busybird Publishing

Layout and typesetting: Busybird Publishing

Illustrations: Ian Findley

Busybird Publishing
2/118 Para Road
Montmorency, Victoria
Australia 3094
www.busybird.com.au

www.ifindbooks.com.au

Contents

Introduction	1
CHAPTER 1 Training Sessions	3
CHAPTER 2 Basic Skill Development - Drills 2.1-2.14 Passing And Catching	7
CHAPTER 3 Basic Skill Development - Drills 3.1-3.9 Spacial Awareness - Passing to Advantage	33
CHAPTER 4 Basic Skill Development - Drills 4.1-4.11 Footwork	56
CHAPTER FIVE Skill Development - Drills 5.1-5.13 The Goal Circle	76
CHAPTER 6 Skill Development - Drills 6.1-6.6 Defense	101
CHAPTER 7 Skill Development - Drills 7.1-7.6 Intercepting	118
CHAPTER 8 Team Defense	140

CHAPTER 9
Skill Development - Drills 9.1-9.5
Team Strategies and Set Plays 146

CHAPTER 10
Skill Development - Drill 10.1
Free Play and Improvisation 166

CHAPTER 11
Observing the Opposition 172

CHAPTER 12
Game Day 177

Chapter 13
Frustrations in Coaching 182

CONCLUSION 195

This book is dedicated to every Coach that has taken on the challenge of coaching Netball. It is also dedicated to every Netball player who loves to play the game and works hard to improve their game.

Introduction

Having fun and good sportsmanship is always a focus while teaching the skills that are needed to play Netball well.

In writing this book my intention has been to keep things simple, short, clear and to the point. Diagrams are included where needed.

I have also included some mental and psychological components that have proven helpful in achieving success. There are a number of examples used throughout this book.

Netball players should be taught that

- possession of the ball should lead to a goal

- when in possession of the ball, all players on the team are attackers

- when the opposition is in possession of the ball, all players on the team are defenders.

If all players on your team know and think this way you are well on the way to developing a cooperative, healthy team spirit.

In Netball, it is important that all players work on and develop both attacking and defensive skills.

In this book there are drills designed to assist both the individual and the team in learning and developing the required attacking, defensive and team skills. These drills and skills are then placed in real game situations that explain when and how they can be used.

CHAPTER 1

Training Sessions

Training sessions should:

- be fun and energetic and include a variety of activities to keep interest and avoid boredom

- contain drills that teach and develop the skills required to play the game of Netball well

- include drills that address and correct skill observed in individuals and team in performance.

Teaching the rationale.

There is great advantage in explaining the rationale behind a skill being taught in training.

"We are doing this to improve our footwork skills. We turned the ball over a lot by stepping last game." I have included the rationale with the drills that follow.

Training should be more doing that talking.

In stating this, I must also state that talking to your players, explaining and teaching both the theory and the practice is important. Keep your talking and explanations to a minimum. Make talk time short, clear and to the point. **Demonstrate the skills where possible.**

Coaches should ask their players what they want from training and what they expect of them. Explore the players goals and how you as the coach can help them achieve them.

Netball is a game of attack (possess) and defense (dispossess). It is a low-level contact sport so players can't tackle or fight to win possession. Players should be taught strategies and skills in both attack and defense. These should form the structure of all training and teaching sessions.

Netball is sometimes played like a continuous game of keepings off. Seven individuals running around willy nilly, all just doing their own thing. The players want the ball but have no plan of what they will do with it should they get it. It is only when they get the ball, do they look around and decide what they will do with it. Although Netball can be played like this, it does not work for long-term success. Very little teaching or forward planning appears to be involved in this style of Netball.

Players need to be taught to think ahead, think like a team, learn how their team members think and play. Using the skills and strategies in this book will help this occur. Real teamwork requires some sort of plan and strategy.

Attack Training.

A team should train for the times in a game when they have possession of the ball. They should work towards learning and developing the skills needed to keep possession of the ball until a goal is scored.

Defense Training.

A team should train for the times in a game when the opposition has possession of the ball. They should work towards learning and developing the skills needed to take possession of the ball from the opposing team.

Training towards keeping possession of the ball until a goal is scored raises the question:

How does a team lose possession of the ball?

- a bad pass: this is often the result of tunnel vision, a skill error, not throwing to the receiver's advantage, poor communication between thrower and receiver, being unaware of other options or panic

- a dropped catch: skill error

- a footwork infringement: this is often the result of over balancing, poor technique, going too fast, not understanding the footwork rule

- held ball: not having a plan, no obvious pass options to make

- throwing the ball directly to the opposition: this can be the result of panic, lack of spacial awareness or playing too fast

- illegal contact: this can be the result of poor defensive skills or simply accidental contact

- poor awareness of where the opposition players are positioned for a possible intercept: this is often the result of tunnel vision and lack of spacial awareness.

Identifying the cause of a turnover informs the Coach of the skills that need to be improved and further developed. This is true for any team at any stage in their Netball development and all these areas require constant attention. Mistakes result in turnovers. Turnovers result in goals to the opposition. In reality, a turnover costs two goals, the one the attacking side has lost, and the one gifted to the opposition. This emphasises the value and benefit of causing a turnover when defending. A goal saved is hopefully a goal scored.

The Coach can now set to work on developing a training/teaching plan. The plan is to reduce the number of bad and misdirected passes, dropped catches, held ball errors, contacting errors, etc. By reducing these errors there will be more opportunities to score, more goals scored, and more goals saved.

While mistakes and skill errors will inevitably occur and are to be expected, working on skill development and improvement is a crucial part of coaching, teaching and will reduce the number of errors made.

Players should:

- develop a growing understanding of their game, skill level, strengths and weaknesses

- be encouraged to commit to developing the required skills to generate improvement.

Coaches should encourage and facilitate this improvement through teaching and training drills.

A Coach is a teacher. Explanation and demonstration of skills and technique cannot be over emphasised.

A Coach showing frustration can become a major problem. Coaches are generally competitive in nature. The Coach's focus should always be one of encouragement, skill development, improvement, learning and fun. Competitive natures need to be held in check. Being too competitive and having too high an expectation can reduce the confidence of the novice player.

Each individual player is more valuable than any game or result. If a player is not enjoying themselves and having fun, the Coach may need to do things differently. People generally enjoy achieving and improving. They will respond best to encouragement and relational teaching. Put energy and effort into training. Habits formed in training come out in games. Players are to be encouraged to practice with the effort and energy that is required in a game.

CHAPTER 2

Basic Skill Development - Drills 2.1-2.14
Passing and Catching

Passing and catching are the most basic of Netball skills to learn. Drills to develop and improve these skills are a must in all training sessions from beginners right through to the more advanced Netballer.

Training drills in ball handling, catching and passing improve and develop skills continually. Drills can be simple and basic for the beginners and they can be increasingly difficult and challenging for the players whose skills are more advanced. The degrees of difficulty can be extended simply by increasing speed, strength and distance.

The goal is to improve, minimise fumbles, move quicker, develop better reflexes and improve communication between players resulting in less mistakes.

Passing and catching exercises

Drill 2.1: Passing and catching

- This drill can be done anywhere there is space on the court.
- This drill is done in pairs with players of roughly equal skill.
- The 2 players stand a half a metre apart facing each other.
- The 2 players hand the ball back and forwards between each other. (hand the ball not passing it).
- Each player only takes their hands off the ball long enough to create a gap before taking it back.

→ This can be done in passes of 10 or as many times as you choose.

→ This can be done as a race with a number of pairs competing against each other to complete a selected number of passes.

Variation.
1. The distance between the players can be increased to 1 metre.

Even though drill 2.1 may constitute a short pass and cannot be utilised in a game of Netball, it is included in training to develop coordination and ball handling skills. This is more suitable for the beginners but can also be fun for others when under speed and competitive conditions for example, the first pair or group to reach ten sit down.

Drill 2.2: Introduction to crossball

- This drill can be done anywhere there is space on the court.
- This drill requires 6 or more players.
- The players form two lines facing each other, approximately one metre apart.
- The two lines are staggered (see figure 2a)
- The ball starts with the player at one end.
- The player who starts with the ball hands it across to the first player in the opposite line.
- This player then hands the ball back across to the second player on the opposite side.
- The ball continues to be handed across to each player down the lines in a zigzag pattern to the end.
- The ball direction can be reversed and the ball can be handed or passed back and forward down the line many times.

Figure 2a

Drill 2.3: Pivot and hand the ball on

- This drill can be done anywhere there is space on the court.

- This drill requires 5 or more players.

- The players form a single line one behind the other about 1 metre apart.

- All players start facing the same direction.

- The player at the front starts with the ball.

- The player with the ball pivots (twists) around to face the second player.

- The second player takes the ball, pivots (twists) around and hands the ball to the third player.

- This process repeats down to the end of the line.

- The ball can be handed up and down the line many times.

ball direction

Start twist hand on twist hand on twist hand on twist etc.

Figure 2b

Drill 2.4: Sideways hand the ball on

- This drill can be done anywhere there is space on the court.

- This drill requires 5 or more players.

- The players stand in a line side by side about one metre apart (see figure 2c).

- The first player at the end starts with the ball.

- This player hands the ball sideways down the line to the second player.

- The second player takes the ball and hands it on sideways down the line to the third player.

- This process repeats down to the end of the line.

- The ball can be handed up and down the line many times.

Figure 2c

Drill 2.5: Passing over the head

- This drill can be done anywhere there is space on the court.

- This drill requires 5 or more players.

- The players stand in a line one behind the other about one metre apart all facing the same way (see figure 2d).

- The first player at the end starts with the ball.

- This player hands the ball over their head to the second player.

- The second player hands the ball over their head to the third player.

- This process repeats down to the end of the line.

- The ball can be handed up and down the line many times.

Figure 2d

Drill 2.6: Passing under through the legs

- This drill can be done anywhere there is space on the court.

- This drill requires 5 or more players.

- The players stand in a line one behind the other about one metre apart all facing the same way (see figure 2e).

- The first player at the end starts with the ball.

- This player hands the ball through their legs to the second player standing behind them.

- The second player takes the ball and hands it through their legs to the third player.

- This process repeats down to the end of the line.

- The ball can be handed up and down the line many times.

Figure 2e

Drill 2.7: Under and over passing

- This drill can be done anywhere there is space on the court.

- This drill requires 5 or more players.

- The players stand in a line one behind the other about one metre apart all facing the same way (see figure 2f).

- The first player at the end starts with the ball.

- This player hands the ball over their head to the second player.

- The second player hands the ball through their legs to the third player standing behind them.

- The third player hands the ball over their head to the fourth player.

- This process repeats down to the end of the line.

- The ball can be handed up and down the line many times.

Figure 2f

Drill 2.8: Left side - right side passing

- This drill can be done anywhere there is space on the court.

- This drill requires 5 or more players.

- The players stand in a line one behind the other about one metre apart all facing the same way (see figure 2g).

- The first player at the end starts with the ball.

- This player hands the ball behind them via their left side without twisting.

- The second player takes the ball and hands it to the player behind them via their right side without twisting.

- The third player takes the ball and hands it to the player behind them via their left side without twisting.

- This process repeats down to the end of the line.

- The ball can be handed up and down the line many times.

left side right side left side right side left side

Figure 2g

Extensions to drills 2.1-8

1. When the last person in the line gets the ball, they run with the ball to the front of the line and it all starts again until the line is back in its original position.

2. Two or three balls can be put in play down the line at the same time. Start the second ball when the first ball is with the fourth person. The aim should be to get the second ball to catch up with the first ball. The number of extra balls included will depend on how many players are participating in the drill and the skill level of the participants.

3. Increase the distance between the players to make things more challenging.

4. Coordinate or synchronize the passes by calling an instruction as when to pass (pass – pass – pass).

5. Do these drills as a race between two or more teams.

In some of these drills you might insist that one foot stay grounded to follow the footwork rule, particularly when swiveling. The footwork rule is explained in chapter 4. The purpose of these drills is to enhance coordination and improve ball handling skills. The players should be pushed to their limit. If the players are not stretched, their skill levels will not improve. There is a lot of fun to be had using these drills.

There are many other activities of this sort and variations that will add fun and variety to your training session. For example, tunnel ball. These activities are limited only by your knowledge and imagination.

As a sports Coach and amateur musical theatre producer/director, I have learnt that habits formed in training come out in games, both good and bad. Similarly, habits learnt in rehearsal come out in performance. Effort and energy are to be encouraged and expected in training. Lazy trainers play lazy Netball.

Players should be encouraged to push their limits. Initially, there will be a lot of mistakes, dropped catches and misdirected passes.

A player who drops the ball consistently, or passes the ball poorly on a regular basis should be encouraged to slow down just a little. It should be emphasised that control is more important than speed.

Push the players to the point they can manage, then a little more. Control first and speed later, but continue to push the level.

The chest pass

The chest pass is used in Netball for quick and shorter distance passes. It is used a lot in feeding the ball in and out of the goal circle, but can be utilised in other parts of the game as well.

The chest pass is made

- holding the ball with two hands at chest level
- passing and catching the ball with both hands
- with the elbows slightly extended outwards and the ball held close to the chest
- with the ball directed to the catcher's chest
- in a spring action, take in and push out, type motion.

The ball is caught

- with both hands, fingers well spread but relaxed
- at chest level
- with arms slightly extended towards the thrower
- with hands moving back towards the chest to cushion the momentum of the ball
- and bounced back in an in-out spring type motion. The action should be smooth and rhythmic.

The Coach should demonstrate this action.

Drill 2.9: Catching drill using the chest pass

- This drill can be done anywhere there is space on the court.
- This drill is done in pairs.
- The 2 players stand facing each other about one metre apart.
- Either player can start with the ball.
- The players pass the ball back and forwards in a spring type action at chest level.
- The Coach chooses the number of passes to make, for example, 50 passes each.

Variation

1. One of the players takes a step backward to increase the distance between them.

Feeling and mastering the rhythm and direction of this drill comes before increasing speed and strength. Increasing the distance between the players develops more strength and control. Crossball can be included to add fun and variety to the chest pass drill.

Crossball drill

- This drill can be done anywhere there is space on the court.
- This drill requires 6 or more players.
- The players form two lines facing each other, approximately one metre apart.
- The two lines are staggered (see figure 2h)
- The players use the chest pass for this drill.
- The ball starts with the player at one end.

Passing and Catching

- The player who starts with the ball passes it across to the first player in the opposite line.

- This player passes the ball back across to the second player on the opposite side.

- The ball continues to be passed across and back in a zigzag pattern down to the end of the line.

- When the ball reaches the end of the line, reverse the direction.

- The ball can be passed up and down the line many times.

Figure 2h

The distance between the lines can vary from being close enough to hand the ball to each other (no gap), to standing metres apart, as long as the chest pass can be managed.

Variation 1

- When the first player has thrown the ball, they run to the end of the line in time to catch the ball when it arrives (see figure 2i)

- The ball is then passed back down the line in the reverse direction.

- The ball travels up and back before the next person runs.

- The player at the end starts it all going again. This player passes the ball across and runs to the other end of the line to catch the ball when it arrives.

- The ball travels up and back before the next person runs.

- The crossball drill continues in this pattern until you run out of space.

- The line will move along the court.

- When out of space, stop and reverse the direction.

This is a fun activity, good for developing fitness, passing, feeding, catching and ball handling skills.

Run to the other end

1 3 5 7 9

2 4 6 8 10
run to the other end
ball path
running path

Figure 2i

Variation 2

Figure 2j

- For this variation you will need 2 or 4 assistants.

- The assistants can be players, helpers or coaches.

- The assistants are placed at the end of the lines, only further back. (see figure 2j Assistant 1 Assistant 2)

- The crossball drill starts and the ball is passed down the line.

- When the ball arrives at the end of the line the player passes to assistant 2.

- After passing the ball the player runs forward around the back of the opposite line towards the front and receives a pass back from assistant 2 at the half way point marked with X.

➲ The player then makes another pass to assistant 1 positioned at the other end. (see figure 2j)

➲ The player runs to join the line at the front and takes a pass back from assistant 1.

➲ The ball is passed back down the line.

➲ The next player at the end of the line does the same thing.

If you have enough assistants, you can position 2 more on the other side to accommodate the players running to that side.

Variation 3

This variation follows the same pattern as above with different footwork skills applied when landing.

 a. The player running jumps and catches the ball landing on two feet. They stop and balance.

 b. The player running catches the ball landing on the front foot. They stop and balance.

 c. The player running catches the ball landing on the back foot. Grounding the back foot first. They stop and balance.

 d. The player running catches the ball landing on the front foot, stopping, stepping on and running forward.

I will be explaining footwork skills and drills in catching the ball on the run in Chapter 4.

Increasing the distance between the players develops strength, coordination and control. The greater passing distance can also make it necessary to use the shoulder pass, which is explained in drill 2.10.

Racing against the clock, or racing against another group taps into the players' competitive spirits. It also aids skill development and a sense of fun to the drill.

If concentrating on footwork skills using these exercises, use one skill at a time. For example, this time all will land on two feet and balance before passing the ball off. More explanation in the section that deals with footwork. (Chapter 4 drill 4.1 – 4.4).

Drill 2.10: The shoulder pass

The shoulder pass is one of the most common passes used in Netball. It is mostly used for longer passes.

- This drill can be done anywhere there is space on the court.
- This drill is done in pairs with partners of similar skill level.
- The 2 players start approximately 2-3 metres apart.
- Either player can start with the ball.
- The players pass the ball back and forwards as described below.
- The Coach chooses the number of passes to make, for example, 20 passes each.

Variations

1. Increase the distance by getting one player to take a step back. Another 20 passes.
2. Keep extending the distance to develop strength, accuracy and control.
3. Change or rotate the partners.

Making the pass:

- The players stand slightly side on with their throwing arm to the back.
- The players place the foot opposite the throwing arm to the front.
- The players stand with their feet slightly apart allowing for good balance.
- The players keep both feet firmly grounded.

- The pass is delivered with one arm using a slight rocking action, transferring the weight from the back foot to the front foot. This helps to propel the pass while keeping both feet firmly on the ground.

- The pass is directed to the catcher's throwing arm. The pass should not be directed at the chest as in the chest pass.

Catching the pass:

- The catcher catches the ball with two hands.

- The catcher extends their arms out in front.

- The catcher has their weight on their front foot and rocks back transferring their weight to the back foot to soften the impact as they catch the ball.

Returning the pass:

- After catching the ball, the player rocks forward again and pushes forward transferring the weight back to the front foot to get more power in the pass.

The Coach should demonstrate. This is a similar spring type action that was used in the chest pass drill, but the transfer of weight is through the legs, which creates the spring action rather than the in-out momentum of the arms. The feet should not move in this drill. The focus is on the accuracy and the strength of the pass. If a player has to move a foot, then the pass is not as accurate as it needs to be. A nice easy rocking rhythm can be established between the partners as they pass back and forwards.

Speed, strength and distance is to be increased over time. 10 to 20 passes at different distances should be included in a training session. Partners may change so the players can get used to different styles and learn how each team member plays. In the initial stages this exercise should not be about speed, it is about technique, control and accuracy. Right-handed pairs should direct the pass to the right hand of the catcher. Left-handed pairs should direct the pass to the left hand of the catcher. If a right-handed person is paired with a left-handed person, the direction of the pass needs to be adjusted accordingly.

After a while, practicing this method regularly results in muscle memory and the actions become natural with little or no thought required. Increasing the strength in the pass is also recommended as skills develop.

The pairs need to understand that their role is not only to improve their own passing and catching skills, but also to extend and develop the skills of their partner. In other words, they need to make each other work to improve.

Iron sharpens iron. Partners may need to be challenged to get the best results. Distance between pairs is to be extended to cover the width of the court or more. You will find accuracy, control, strength and effectiveness of the pass will decrease with the extended distances. This should be discussed with the players so they know and can identify where they are at regarding their passing skills, for example, "Last time we managed 6 out of 10 effective passes at a distance of 5 steps. This time we managed 7 out of 10 at seven steps."

The players should be encouraged to work at improving their outcomes the next time the drill is done. Some players may like to keep a diary. Encourage the players to do better by reminding them that a bad pass or a dropped catch leads to a turn over and a goal to the opposition.

Using the shoulder pass in crossball

The earlier drills can be adapted to include the shoulder pass. The distances may need to be adjusted. (Drill 2.9) You might compare the speeds between the chest pass with the shoulder pass for the same drill, or have two groups using the different pass techniques at the same time to compare over varying distances.

Drill 2.11: The shoulder pass - the non-preferred arm

The shoulder pass exercise can also be done using the non-preferred arm. This assists in coordination, strength and ball handling skills, but is also a good laugh and works best when treated as such. Encourage the players to laugh with each other, not at each other. Training needs to be fun and there is nothing as good as a good laugh every now and then.

- This drill can be done anywhere there is space on the court.
- This drill is done in pairs with partners of similar skill level.
- The 2 players start approximately 2-3 metres apart.
- Either player can start with the ball.
- The players pass the ball back and forwards as described above.
- The Coach chooses the number of passes to make, for example 20 passes each.

Variations

1. Increase the distance by getting one player to take a step back. Another 20 passes.
2. Keep extending the distance to develop strength, accuracy and control.
3. Change or rotate the partners.

Drill 2.12: The overhead pass and catch

Passing and catching the ball with two hands above the head is another form of passing that can be added to the drills above. This can be done in pairs or in groups using the crossball activity or the other drills already introduced (drill 2.9).

- This drill can be done anywhere there is space on the court.
- This drill is done in pairs with partners of similar skill level.
- The 2 players start approximately 1-2 metres apart.
- Either player can start with the ball.
- The players pass the ball back and forwards as described below.
- The Coach chooses the number of passes to make, for example 20 passes each

Variations

1. Increase the distance by getting one player to take a step back. Another 10 passes.
2. Keep extending the distance to develop strength, accuracy and control.
3. Change or rotate the partners.
4. Do a crossball activity using the overhead pass.

Players need

- to keep their backs straight
- watch the ball all the way into their hands
- keep their heads up
- direct the ball above the catcher's head.

Overhead passing is not common in Neball but can be used to great effect when required and mastered.

Drill 2.13: Passing and catching with one hand

Even though discouraged in a game, practicing to catch, throw and control the ball with one hand assists in the development of ball handling skills. Many of the above drills can be adapted and done with one hand. Speed is not the goal, ball control is.

Individual passing and catching with one hand

If you have enough Netballs for every player to have their own ball at training, and have access to a brick wall, throwing the ball one handed against the wall and catching it with one hand at varied distances, is another good training exercise. Even catching the ball with two hands can be beneficial. For players with developed skills, doing this fast and close to the wall one handed is good for reflexes and ball control. The players should be encouraged to avoid batting the ball and to feel it comfortably in and out of the palms of the hand. They should be able to stop at any time and have the ball balanced and controlled in the one hand.

- This drill requires a brick or solid wall.
- This drill is done individually.
- The player starts at a distance of approximately half a metre from the wall.
- The player balances the ball in one hand and bounces it off the wall at about shoulder height.
- The ball should be caught and controlled in the one hand.
- The players concentrate on the action as described above.
- The ball is bounced off the wall 50 times with one hand.

Variations

1. Swap to the other hand.
2. Increase the distance.

3. Use both hands and develop a pattern. Right to right hand, left to left hand, right to left hand, left to right hand.

4. Do a crossball activity using only one hand.

This one-handed exercise can also be done in pairs when a wall is not available. Using a brick wall to increase strength and reflexes is also valuable for individuals who wish to improve their chest and shoulder passing as well as catching.

Drill 2.14: Passing and catching with one hand extension

- This drill can be done anywhere there is enough space.
- This drill is done in pairs.
- The players stand approximately half a metre apart facing each other.
- The ball starts with either player.
- The player starting with the ball balances it in one hand and directs it towards the waiting hand of their partner. Right to left hand.
- The ball should be caught and returned using only one hand.
- The players concentrate on controlling the ball.

It is easier to develop a pattern first. Two passes each on the same side then swap to the other. For the more advanced players, they may pass to either hand at any time to work each other's reflexes, concentration and skills. Some players like to jog on the spot while doing this drill.

Variations

1. The players change hands.
2. The players develop a crisscross pattern that involves passing diagonally to the partner's other hand.
3. The players can work out their own pattern.

This is not just a drill for the more advanced Netballer. The one-handed pass and catch can be introduced to players of all levels as it will assist them in improving their ball handling skills and even their confidence.

There is value in setting up a training schedule that has a set drill plan for the players to follow. For example. A warm up exercise, a number of catching drills each, 50 of these, 50 of those, etc. There is no limit to the amount of throwing and catching exercises that can be used for fun and

variety in training. If all players have their own ball at training there are many more exercises that can be done individually to improve their ball handling skills. Passing the ball around their waist, between and around their legs or neck, spinning and balancing the ball on one finger are examples of this. These drills are only restricted by your knowledge and imagination. There are further catching and passing drills in the sections of this book that deal with footwork and balance.

CHAPTER 3

Basic Skill Development - Drills 3.1-3.9

Spacial Awareness - Passing to Advantage

So far, we have concentrated on the basics of passing and catching. In a game of Netball there are two teams on the court and that makes the skills of passing just a little bit more complex and challenging. A successful pass has two components. The pass and the receive. Two players are involved. One needs to throw the ball, the other needs to catch it.

In theory, the rules of Netball and the space available on the Netball court, provide the team in possession of the ball with an enormous advantage. The person with the ball has 0.9 metre space around them that cannot be encroached on. The receiver has a lot of court space to use to their advantage if they know how.

Netball players need to be taught spacial awareness and where to pass the ball to provide the catcher with the best opportunity of receiving it. If space is available and the thrower and the receiver communicate well and work together, the pass should always be successful. Other players on the attacking team need to be aware of the space available so they do not assist the defense by entering and closing down that space.

Using the body to protect space

Even though Netball is a low-contact sport, the body can be used to advantage to protect and create space.

In junior Netball, particularly at a young age, players are often seen trying to pass the ball directly to another player, as they might do in a training exercise where there is no opposition.

In most instances the problem is that the thrower tries to pass the ball directly to the catcher and is not aware of the space the receiver has

around them. Both the thrower and the receiver need to work together, be aware of the space and learn how to use it to their advantage. This can easily be demonstrated by a Coach at training when teaching spacial awareness. The Coach demonstrates this by standing beside a player and then asks another player to throw the ball to the player who he/she is standing beside. The Coach will have no problem in batting the ball away. This should be explained and talked about with the team. "How many times have we as a team turned the ball over in this way? When we turn the ball over, we give the opposition a goal" (more psychology). This is how the players will learn.

Demonstration of protecting space and positioning the body

The Coach demonstrates how to turn the body sideways, away from the defender, how to use the body to block the defender from moving into the space they are protecting (often known as holding). The thrower only needs to drop the ball about an arm's length to the side into the protected space and the defender has no chance of intercepting the ball without making contact. Demonstrate this as you did when batting the ball away. If you as the Coach cannot demonstrate, get an experienced Netball player to do so.

The hands and/or body position should be used by the receiver to communicate to the thrower where they want the ball. The thrower should know where the receiver wants the ball just by the way the receiver has positioned their body. Therefore, it must be accepted that if a receiver hasn't positioned themselves well to receive the pass and the ball is turned over, it may not be the error of the thrower. It possibly is a communication breakdown between the two.

Space all around the receiver

In reality, there is space all around the receiver. There is space in front, if not, there is space at one side, if not, there is usually space behind. If a player is completely hemmed in there must be at least two other players who are free to take the pass. Players need to be taught to consider all the options. They need to be taught about space, how to create it, how to protect it and how to pass to it. If the first or preferred option to pass is blocked, or the player is not in position to receive the pass, there should always be a second and a third option.

If a team has even the most basic of game plans, options should always be known and available. Many Netball teams play without any idea of

options, structure or plan in a game. More about this later. In stating this, I need to acknowledge that at beginner levels, players are really only learning about the game, the basic skills and rules, therefore are too inexperienced to understand or implement game structures and plans. However, learning about space and passing to advantage can be learnt early if taught.

Space is your friend when in attack

Throwing to space. If we teach and train Netball players to become aware of the space on the court and not just the players, and we teach them that the space is their friend, we are establishing a very positive place from which to play some very exciting Netball. Space is our friend. Learning how to use that space to advantage becomes the challenge. Most Netballers look for a player when they have the ball, as they do in the ball handling drills so far covered.

Consider what might occur if a player looks for a space rather than a player when they get the ball. This is a different mindset. But when the receiver has the same mindset and moves into that space, the pass is complete and successful.

I can remember many years ago when I was coaching in an interstate Netball carnival. One of the opposition Coaches was heard to say, "They just seem to throw the ball to nowhere and all of a sudden someone is there".

Throwing to space is not a random action. It is not just any space. It is a planned created space. The pass has been planned and practiced many times. Even though throwing to a space may appear to some as random, it is not. The thrower is aware that there should be a player moving into that space and has to observe if it is happening.

If for some reason the catcher is not moving into that space, then there should be a plan B. The thrower is aware that a space exists and that a receiver will be moving into that space. The thrower then has to execute that pass with as much skill as the receiver has to display to complete the pass. They need to communicate and work together.

In general play, all players need to be taught to observe space and take in what is happening around them. Players need to develop the ability to think and plan ahead. Players should be aware of the spaces around them. They should know how to create and protect space. They should be thinking about how they might use that space if the opportunity should present.

Scenario

I will include an example here from my many years of observation.

The ball is in the opposition team's goal third. The opposition have possession. Our GA and WA are standing across the middle of the court observing. They are actually occupying the very space they might need. The ball is turned over by the defense. The defender looks up and sees the GA and WA standing there and directs a pass at one of them. A clever, observant opposition GD or WD has summed up the situation and has set themself up behind for an intercept. The long pass is clearly cut off by a dashing defender. It looks spectacular.

In this scenario it is obvious that the GA and WA had become observers and had no expectation or plan should there be a turnover. They were not thinking or planning ahead. They were not aware of the space they might need and how they might use it.

Scenario follow-up

Imagine what might be different if the GA and WA are ready and were anticipating an intercept.

They are thinking and planning ahead. They are aware of the space they will need, how to create it and how they will use it if the opportunity arises. They have communicated with each other and they know the team plan and who will make the play, so they don't get in each other's way. They know what they will do when the opportunity arises. They stand back and position themselves on the transverse line to create space in front to run into. They position themselves on opposite sides of the court to cover options on both sides. They are aware of where the opposition defenders are and adjust their position to accommodate for this. When the intercept occurs, one runs forward into the space they have created and receives the pass. Little chance of an intercept because they are running into the space and not standing still.

Netball players should be taught to anticipate, think and plan ahead, set themselves in positions to utilise the spaces created. Coaches may need to direct their players in this. For example: when the ball is in this position WA you start from this position, don't move into the space the GA has created. Then when the GA has taken possession run hard to the corner.

There are many scenarios in a game where 'throwing to space skills' can be used to great advantage by all players. All players are passers and all players are receivers in Netball. Throwing to space has proven most

effective in the goal ring when passing to either the GS or the GA. A one-on-one with a defender provides the perfect opportunity to utilise this skill. Space in front, space to the sides, space at the back. It only takes the mindset, knowledge and skill and the goaler will get the ball every time.

The drills that follow are designed to create spacial awareness and develop the skills required in passing to space.

Rationale

These drills are included to teach:

spacial awareness

- body positioning in attack
- passing to advantage using space.

Mastering these skills minimises bad passes, improves passing and catching skills and will results in less turnovers. A turnover is a goal to the opposition (Psychology). There are many exercises and training drills that can be used to develop this awareness and skill set.

Drill 3.1: Passing to the outstretched arms to the sides

Space at the sides

- This drill can be done anywhere there is space on the court.
- This drill requires 3 players, a thrower, a catcher and a defender.
- The thrower and the catcher stand facing each other about 2 metres apart.
- The defender stands to one side of the catcher.
- The catcher positions their body making sure their back is to the opposition to block them from entering the space on the side where they want the ball.
- The thrower starts with the ball.
- The catcher indicates with their arms where they want the pass.
- The thrower directs the pass to the space on the side away from the defender.
- The catcher grounds the foot closest to the defender and takes one step to the side being careful not to drag the grounded foot.
- The thrower passes the ball to the hands of the outstretched arms of the catcher.
- Both sides of the body should be developed.

At this stage there is no need for the defender to attempt to intercept the ball. After the skill is grasped attempts to defend can be introduced

Variations

1. The catcher jumps to the side.
2. The catcher runs to the side.
3. Increase the distance of the pass.
4. Activate the defender.

Drill 3.2: Passing to the outstretched arms to the front

Space at the front

An extension to drill 3.1, is for the receiver to position their body so the defender is caught behind them, and to lunge or step forward with outstretched arms to receive the pass, without moving or dragging the back foot.

- This drill can be done anywhere there is space on the court.
- This drill requires 3 players, a thrower, a catcher and a defender.
- The thrower and the catcher stand facing each other about 2 metres apart.
- The catcher positions themself in front of the defender.
- The catcher positions their body making sure their back is to the opposition to block them from entering the space in the front where they want the ball.
- The thrower starts with the ball.
- The catcher grounds the back foot and stretches forward with the other foot, puts the arms out in front to indicate where they want the pass.
- The thrower directs the pass in this case to the hands of the catcher.
- The thrower passes the ball to the hands of the outstretched arms of the catcher.

At this stage there is no need for the defender to attempt to intercept the ball. After the skill is grasped attempts to defend can be introduced.

Variations

1. The catcher jumps to the front.
2. The catcher runs to the front.
3. Increase the distance of the pass.
4. Activate the defender.

Drill 3.3: Combine passing to the side and to the front

A further development of drill 3.1 and 3.2 is for the catcher to position their body to take the pass either on the side, or to the front, and the thrower has to read the position and make the pass. The catcher returns the ball to the thrower who continues the drill. This can move faster and faster keeping the defender off balance and out of the play. This is a communication drill between the thrower and the catcher.

- This drill can be done anywhere there is space on the court.

- This drill requires 3 players, a thrower, a catcher and a defender.

- The thrower and the catcher stand facing each other about 2 metres apart.

- The catcher positions their body making sure their back or their side is to the opposition to block them from entering the space where they want the ball. This will be either be to the front or to the side.

- The thrower starts with the ball.

- The catcher uses both the techniques learnt in 3.1 & 3.2 to create and use the space to the front and the sides.

- The catcher quickly returns the ball to the thrower and moves to make another position.

- The thrower needs to read the catcher's body movements and put the ball in the right place.

Drill 3.4: Jumping into the space to take a pass

A further development of these drills is for the catcher to take the pass a bit further in front or further to the side by running and jumping into the catch. A bit more space is needed for this. Increase the distance between the thrower and the catcher to about 5 metres. Begin with the catcher landing on two feet well balanced. Insist they hold the balanced position for three seconds before passing the ball back (refer Chapter 4). Again, this is practiced to the front and to the sides.

- This drill can be done anywhere there is space on the court.

- This drill requires 3 players, a thrower, a catcher and a defender.

- The thrower and the catcher stand facing each other about 5 metres apart.

- The catcher positions their body making sure their back or their side is to the opposition to block them from entering the space where they want the ball. This will be either to the front or to the side.

- The catcher positions their body to block the defender from entering the space they want to run to.

- The thrower starts with the ball.

- The players use the techniques learnt in 3.1 - 3.3 to create and use the space to the front and the sides.

- The catcher returns the ball to the thrower and moves back to the defender to set up again.

- The thrower needs to read the catcher's body movements and put the ball in the right place.

Drill 3.5: Passing to the space behind - the lob pass

The space behind is a space that is not utilised enough or well in Netball. The lob pass is a pass that goes up and over to the space behind the catcher. The catcher stands behind an opposition player using their body to hold them under the ball and from moving back. Once the pass has been made the catcher moves back into the space behind to take the pass.

Lob pass

Figure 3a

As stated earlier, the GA or GS positioned well in the goal circle has space all around them. Passing to the space behind can be utilised effectively from positions all over the court. Passing to the space behind is something that needs to be taught and practiced consistently.

- This drill can be done anywhere there is space on the court.

- Place a mark on the court with some sort of marker. Could be a coin, a piece of tape, chalk or anything that is not going to prove a safety issue for the players to trip on.

- This drill requires 3 or more players, a thrower(s), a catcher and a defender.

- The thrower starts at about five metres from the mark on the court.

- The catcher and the defender stand together about 3 metres from the thrower. The defender is in the front of the catcher who stands closely behind. The 3 players should form a straight line with the mark on the court. (see figure 3a)

- The mark on the court is about 2 metres behind the catcher. (see figure 3a)

- The catcher positions their body using their side to block the defender from getting anywhere near the mark.

- The thrower starts with the ball.

- The thrower passes the ball using a lob pass, up and over to land the ball on the mark.

- The catcher does not attempt to catch the ball at this stage. The focus is for the thrower to hit the mark.

- The defender need not move to defend but may do so if the pass is not high enough to clear them.

- The focus is to clear the defender and land the ball on the mark placed on the court.

- There can be a line of throwers who take their turn landing the ball on the mark.

- It is important to get this part right before moving on.

Holding the defender under the ball

The catcher positions behind the defender to hold the defender from moving back. The catcher uses their body in a side on position. The catcher does not attempt to catch the ball at this stage. The catcher's role is to hold the defender from moving back into the space where the mark is. The catcher can only hold using their body, they cannot use their arms in any way. The catcher needs to stand strong because the defender will most likely push back.

The lob pass part 2
- Repeat the above exercise. (3.5)

- This time the catcher holds the defender from moving back with their body, allows the ball to bounce once, then runs back to catch the ball before it bounces a second time.

The lob pass part 3
- Repeat the above exercise. (3.5)

- This time the catcher holds the defender from moving back with their body, steps back after the ball has passed, and catches the ball on the mark before it bounces.

Please note that once the defender and the receiver have been activated in these drills the focus tends to unconsciously change for the participants.

- The thrower is in the habit of passing to a person not a space or a mark.

- The thrower is in the habit of looking for a player and not the space they have around them.

- The catcher is in the habit of going to the ball and not protecting the space behind them.

Habits are hard to break but this is really worth persevering with. Every player should learn the pass, the hold and the catch. The more lob passes they practice the sooner they will get it right.

Problems to be avoided

The ball lands short of the mark because the thrower is concentrating on getting the ball to the catcher and not hitting the mark. Teach the players to mentally picture the mark on the court. Throw to the **space or mark, not the player.**

The catcher moves back too soon and allows the defender to move back with them into the space. **The catcher must hold their position until the ball has passed over their head**. It's all about timing. Do not move back until the ball has passed.

The catcher often stands in a side on position and indicates that they want the ball behind them with an out stretched arm. Demonstrate these gestures. The thrower has got to avoid the temptation of throwing the ball to that arm and concentrate on the mark on the court. Of course, in a game situation there are no marks on the court. However, it doesn't take much to teach your players to visualise the spot in their mind.

Drill 3.6: Lob pass into the goal circle

Move this drill into the goal circle

- Practice the lob pass with the thrower outside the goal circle, passing into the circle.

- The catcher, who now is the goaler, identifies a position in the circle where they would choose to shoot from if given the choice. I will refer to this spot as the 'goaler's preferred position' (GPP).

- For practice, place a mark on the court with tape, chalk or a coin to indicate this preferred shooting position.

- This position should not be too close to the base line. The goaler positions themself behind a defender in a position to protect this spot.

- The goaler positions themselves so the spot and space is behind them.

- A defender should be included in this exercise.

- The goaler needs to have space behind them and sets up in the circle to create this.

- The lob pass into the circle is made as in drill 3.5.

- The goaler holds the defender under the ball until the ball has passed over their head.

- The goaler jumps back onto the mark to catch the ball

- The goaler may use an arm gesture to indicate where they want the ball.

- The goaler is the manager and controller of this space. The goaler may shoot the goal to complete the play. Vary the throwing position from outside the circle. The mark can be moved to accommodate this. In a match situation it is important that the other goaler does not enter this

space. The other goaler should only enter the space after the goaler has taken possession of the ball. They do so to position themselves for a rebound opportunity should the shot miss (refer positioning for rebounds drill 5.1). **The goaler who is in the goal circle first and sets up, has the right to the space.**

The lob pass can also be made from within the circle from one goaler to the other. Identifying the space and positioning will become easy and natural over time. This one-on-one position in the goal circle allows for a number of different pass options into the circle. At the moment we are learning about the lob pass option which generally allows the goaler to shoot from their preferred shooting position.

In the event that the defender has taken up the space behind, the pass will go to the front or to the sides. It's all about reading the game and passing to advantage. Good communication and understanding will develop between the feeders and the goalers with practice.

In the event that the goaler has two players defending them, one in the front and one behind, the other goaler drives in front of the defender to accept the pass in. The lob pass is unlikely to work when the defenders have a two on one advantage.

Drill 3.7: Lob pass in other positions on the court

A throw-in from the base line GK to GD, WD or C

The receiver positions themself a few metres in on the court and behind the opposition, holding and blocking that player from entering the protected space.

```
GK passes to
space behind
the GD
```

GK Opp. GA GD

```
GD holds the
opposition player
under the ball
```

figure 3b

The pass goes over the top into the space behind, to where the catcher will move.

- Thrower throws in from the base line.

- Catcher sets up behind a defender a few metres in from the line. There must be space behind.

Spacial Awareness - Passing to Advantage

- Mark a spot on the court with tape, chalk or a coin to aim at, as in drill 3.6. I recommend this for practice.

- All players should practice both the throw and the catch.

- Include footwork and catching skills when learnt (chapter 4).

Variation

1. Set up and practice from different throw-in positions around the court.

The lob pass can be used in general play but most often the ball is moving too fast to set it up quickly enough. Using the lob pass does not guarantee success. If the other players on your team do not understand what is happening and do not stay out of that space, the pass will fail.

For example, *The GK has a base line throw-in. The GD takes up position to receive a lob pass from the GK. If the C or WD run into the space the opportunity is lost. They are closing down that space and drawing the opposition players into it.*

I will focus more on this later when I talk about game strategies. Practicing the lob pass should be a regular part of every practice session.

Drill 3.8: Passing to space in the pockets

A very important part of every Netball game is using the space in the corners (commonly referred to as the pockets) outside the goal circle, usually taken up by the WA and C. It important that all players learn and develop these skills. Picture the goal circle as being the right-hand side of a clock face from 1 o'clock to 5 o'clock, 3 o'clock being the middle of the court or the top of the circle.

Stage 1

- This drill is done in and around the goal circle.
- There is no limit to the number of participants in this drill. Half will be throwers and half will be catchers.
- The catchers form a line starting at around 2 o'clock outside the goal circle.
- The throwers form a line starting in the goal circle around 4 o'clock.
- The ball starts with the first thrower in the line.
- The first thrower passes to the 1 o'clock position.
- The first catcher starts on 2 o'clock and drives to the corner to take the pass.
- The catcher moves into the space to receive the pass, landing balanced on two feet.
- The catcher holds the position and balances for three seconds (refer Chapter 4 Footwork).
- The catcher returns the ball to the next thrower.
- The second thrower passes to the second catcher and so on.
- Remember to throw to the space not the player.

Spacial Awareness - Passing to Advantage

Catcher holds defender on the ring and runs to pocket

Receiver runs into pocket to take the pass

start

Thrower passes to corner

figure 3c.

Stage 2 Add a defender

- The second catcher in the line acts as a defender to the first catcher.

- The defender chases the catcher in to the corner.

- The catcher positions their bodies to block the defender and keep them out of that pocket space.

- Start with a defender in position but not defending.

- When the timing and direction of the passes are acceptable, activate the defender. If the receiver moves too early the defender can follow.

- Timing is important for both the thrower and the catcher who need to work together.

Variations

Repeat this drill 3.8 starting the thrower at:
1. the 3 o'clock position (top of the circle)
2. the 2 o'clock position
3. the 4 o'clock position.
4. repeat drill 3.8 using the opposite corner.

Throwing the distance across the circle into the pockets may prove difficult for some players but they should work towards this goal. If this is the case make the circle smaller for the exercise. At first, work on the pass distance and accuracy before introducing the drive into the corners. This has been covered earlier in the shoulder pass section, increasing the distance and strength (Drill 2.10).

Drill 3.8 is a matter of communication and timing. Start the across-the-circle pass drill with a defender in position but not defending. This allows the players to concentrate on direction, timing and holding first. Having the defender standing in position, even though not defending, aids the thrower in remembering to throw to the space. It also aids the catcher to remember to hold and not to move too soon. Without the defender standing in position the temptation exists to throw the ball directly to the catcher. This, of course, is acceptable if the catcher is not being defended. **Speed, distance and strength** of the passes should be added later and adapted to skill levels.

In a game situation, if the catcher finds themselves too far into the corner, teach them how to roll around the defender to the inside. There is no value being trapped in the corner. The roll can be added to these drills to receive the ball on the other side of the defender where there is more space.

This drill needs to be taught as throwing to the space and not directly to the player. A pass directed straight at the player is more likely to be intercepted or batted away. The pass should always be directed to the catcher's advantage. This will depend on what side the defender is positioned. Remember, the catcher should not move into that space too early to minimise any defense attempts. It's all about timing and communication.

Drill 3.9: Passing into the pockets from the centre third

- This drill requires half the Netball court.

- A mark is placed on the court with tape, chalk or a marker. This mark is positioned in the goal third, about five metres in from the base line and approximately half way between the side court line and the goal circle line. The mark is on the same side of the court as the thrower (see figure 3d).

- There is no limit to the number of participants in this drill. Half will be throwers and half will be catchers.

- The catchers start from the transverse line on the opposite side of the court to the throwers (see figure 3d).

- The catchers drive across the court towards the mark.

- The throwers form a line starting in the centre third on the same side as the mark (see figure 3d).

- The ball starts with the first thrower in the line.

- The thrower (refer drill 3.5) executes a lob type pass aimed at landing on the mark placed on the court. Practice this pass before the catcher is introduced.

- The catcher runs diagonally across the court towards the pocket to the mark placed on the court. The catcher jumps and lands on the mark. They will be running away from the thrower at about a 45° angle. Practice the run, jump and land before the pass is engaged. This pass and play are utilised later in one of the set plays (drill 8.3).

- The thrower times the pass so the player catching the ball gets there at the same time as the ball. Timed well, the player catching will land with the ball on the marked spot.

- The catcher should land with the correct footwork and prove they are balanced for 3 seconds before moving

Spacial Awareness - Passing to Advantage

away. Overbalancing may result in the loss of possession for a footwork infringement.

- The ball is returned to the next thrower and the next catcher runs.

- All players rotate. The throwers become catchers and the catchers become throwers.

figure 3d.

Thrower position. Passes to spot on the court

Catcher starts here. Runs across court to the corner, timing the run with the thrower, to catch the ball on the X.

Ball path ⟶ Running path ⟶

This exercise can be broken up into parts. Every player should have a turn at passing to the spot. The catcher can then be added. The Coach may act as the thrower or the catcher. However, in the end, all players need to master the throwing and the catching. The exercise should also be done in reverse on the opposite side of the court.

CHAPTER 4

Basic Skill Development - Drills 4.1-4.11

Footwork

The footwork rule is not greatly understood by many young Netballers. A footwork infringement turns the ball over and presents a goal opportunity to the opposition.

The footwork component is as much a part of the method as are the passing and the catching components. An understanding of the footwork rule is a must for all Netball players.

When catching the ball, a player is either:

- standing still with two feet on the ground
- in the air
- jumping or running forwards
- moving sideways
- moving backwards.

Explanation of the footwork rule

The foot that a player lands on when catching the ball is considered the "grounded" foot. The grounded foot can be lifted but cannot be re-grounded before the ball is released. Players who develop the habit of always landing on their back foot are at an increased risk of a footwork infringement (stepping).

There are situations where:

- a player is best to land on two feet
- a player is best to land on one foot

- a player is best to land on the front foot

- a player is best to land on the back foot.

front foot back foot

figure 4a.

Learning the basics for each is important. A major focus should always be on balance. When landing on two feet there is always the problem of uncontrolled speed or overbalancing. Drills on catching with balance are essential.

Drill 4.1: Footwork - Throwing to space, jumping into the catch

- This drill can be done anywhere on the court where there is enough space.

- This drill has 1 thrower and a line of catchers standing one behind the other.

- The catchers are positioned about 10 metres from the thrower.

- The thrower starts with the ball.

- The first catcher runs forward towards the thrower, catches the ball in the air and lands on two feet.

- The catcher stands still for three seconds to prove they are balanced and in control.

- The catcher returns the ball to the thrower and returns to the back of the line.

Variations

1. The catcher leads out sideways to change the angle.

2. The catcher leads out to the other side.

catchers

thrower

ball path
Running path

figure 4b.

Drill 4.2: Footwork catch and pivot

The catcher jumps to take the pass, lands on 2 feet so they are facing the thrower, pivots and passes on to the next player.

- This drill requires the length of the whole Netball court.

- The players are in groups of four.

- The players are positioned equally along the length of the court, one on each of the transverse lines.

- The ball starts with the player at the end.

Ball starts here | catcher drives forward, pivot and pass | catcher drives forward, pivot and pass | catcher drives forward, pivot and pass

ball path
running path

figure 4c.

- The first catcher leads towards the thrower from the first line.

- The thrower passes the ball at a comfortable height for the catcher to jump into the pass.

- The catcher jumps to take the ball in the air landing on 2 feet still facing the thrower.

- The catcher pivots 180° to face the direction from which they came. The pivot is made in the direction of the non-throwing arm (left for a right-handed and right for a left-handed thrower).

- The catcher stands still for three seconds to prove they are balanced and in control.

- This catcher now becomes the second thrower who passes the ball to the third person, who leads forward into the pass and does the same thing.

- The drill can be reset and done again rotating the positions.

Drill 4.3: Footwork - catch and twist

- This drill requires the length of the whole Netball court.
- The players are in groups of four.
- The players are positioned equally along the length of the court, one on each of the transverse lines.
- The ball starts with the player at one end.

Ball starts here

catcher drives forward, pivots 180° in the air lands balanced passes on

catcher drives forward, pivots 180° in the air lands balanced passes on

catcher drives forward, pivots 180° in the air lands balanced passes on

ball path
running path

figure 4d.

- The first catcher leads towards the thrower from the first line.
- The thrower passes the ball at a comfortable height for the catcher to jump into.
- The catcher jumps to take the ball in the air and twists 180° to be facing the direction from which they came. The twist is made in the direction of the non-throwing arm.
- The catcher stands still for three seconds to prove they are balanced and in control.

- This catcher now becomes the second thrower who passes the ball to the third person, who leads forward into the pass and does the same thing.

- The drill can be reset and done again rotating the positions.

Depending on space you may be able to include more groups at the same time. Landing on two feet is essential with balance and control as the focus.

The footwork rule when landing on two feet: one foot can be lifted and re-grounded, it doesn't matter which foot. The second foot can be lifted but cannot be re-grounded.

Drill 4.4: Footwork - adding a step

Repeat drill 4.2 & 4.3 and add a step

- The catcher, after taking the catch, completes the twist or pivot, landing on two feet and balances.

- The catcher takes one step forward towards the next catcher before passing the ball. It looks as if they are just walking off.

- The second foot (back foot) can be lifted but cannot be re-grounded before the ball is released.

- It does not matter which foot is used to take the step forward provided that both feet have landed at the same time.

- Keep the movement as relaxed and natural as possible as if they are just walking off.

The Coach should also demonstrate the wrong way to do it so the players know what a stepping infringement looks like. The rule should be explained clearly. Constant steady reinforcing of this skill will result in a natural action and muscle memory over time. Catch and step on can be added to the other catching drills where the player lands on both feet.

Drill 4.5: Footwork - jumping into a pass from side to side

- This drill can be done anywhere on the court where there is enough space.

- This drill is done in pairs, one player is the thrower and one is the catcher.

thrower

ball path
running path

figure 4e.

- The players start approximately two or three metres apart.

- The thrower starts with the ball, standing still.

- The catcher runs a few metres to one side, jumps into the catch, twists their body in the air to be facing the thrower, lands on the inside foot (back foot), stepping

to the outside foot or front foot for balance and to push off back the other way. Using the diagram figure 4e, the catcher when running to the right will use their left foot as the inside foot (back foot) and their right foot as the outside foot to balance and push off back the other way. When the catcher is running to the left they will use their right foot as the inside foot (back foot) and their left foot as the outside foot to balance and push off back the other way.

- The catcher holds for a few seconds to demonstrate balance.

- The catcher passes the ball back to the thrower.

- The catcher runs a few metres to the other side, jumps into the catch, twists their body to be facing the thrower, lands on the inside foot, stepping to the outside foot for balance and to push off back the other way.

- The thrower directs the ball to the space in front of the catcher at a comfortable catching height and distance.

- the players swap roles.

Once balance is not an issue, the few seconds hold can be left out and replaced with some speed. Effort and energy should be injected. Remember habits formed in rehearsal come out in performance.

Variation

1. The thrower and the catcher start closer together.

2. The thrower uses a small lob pass over the left shoulder of the catcher.

3. The catcher turns slightly to their left, runs back a few steps, catches the ball and returns it to the thrower.

4. The catcher returns to the middle starting position.

5. The thrower uses a small lob pass over the right shoulder of the catcher.

6. The catcher turns slightly to their right, runs back a few steps, catches the ball and returns it to the thrower.

7. The catcher again returns to the middle starting position.

Drill 4.6: Footwork - catching on the front foot

Running forward and catching the ball landing on the front foot is a great skill to master. It allows the player to use the second foot to balance or move the ball on quickly if the opportunity presents. Players who catch on the back foot often look as though they are skipping or hopping to catch the ball.

- This drill can be done anywhere on the court where there is enough space.

- This drill is done in pairs, one player is the thrower and one is the catcher.

- The players start about 10 metres apart facing each other.

- The thrower starts with the ball and stands still.

- The catcher runs towards the thrower, jumps and catches the ball landing on the front or leading foot.

- The back foot steps forward to balance and stop momentum. Be careful not to lift and re-ground the landing foot. The balancing foot can be placed in front or behind the landing foot.

- The players swap roles.

Drill 4.7: Footwork - running on

Running on in a straight line, catching and releasing the ball without altering the running stride is a great skill to master. This looks great and professional if done without any hopping or skipping. Players learn to time and measure their steps so they take a pass while landing on their front foot. This is not difficult, but for some it may take some perseverance.

- This drill requires about half the court.
- There is no limit to the number of participants for this drill.
- The players form a line one behind the other.
- The Coach acts as the thrower in this drill.
- The Coach stands about 10 metres away.
- The Coach starts with the ball.
- The players take turns to run forward towards the Coach to take a pass on the run.
- The players count their steps as they catch the ball and run on.
- The front foot which they land on is counted as 1.
- The next step as they continue to run on is counted as 2.
- As long as the ball is passed back to the Coach before step 3 there is no stepping infringement.
- The players count 1, 2 and pass the ball back: 1, 2 and pass; 1, 2 and pass, etc. It acts like a repeating rhythm.
- The next player in the line runs forward and so on.
- The players that have run through return to the end of the line.

When a player is running on, they can cover about 3 metres before they need to dispose of the ball. I prefer the players to be able to run through, take and release the ball without altering their running stride in any way. Too many players hop and jump around when catching the ball on the run. If a player catches the ball on the back foot while running on, they greatly increase the chance of a footwork violation. The back foot, in this case the landing foot, once lifted cannot be re-grounded. Remember, a turnover is like giving a goal to the opposition.

Drill 4.8: Train tracks

- There is no limit to the number of participants in this drill.

- The players form two equal lines.

- The two lines position themselves one behind the other facing the other line, about ten metres apart.

- The first player in one of the lines stars with the ball.

- The first player in the other line runs or walks forward across the court towards the ball holder.

- The player with the ball passes it to the player who is running or walking towards them.

- The players do not stop when they catch the ball, they keep running or walking through and pass the ball to the next player in the front of the other line who is now moving towards them.

- The players, once they have passed the ball on continue to run or walk to the end of the opposite line they came from.

- The steps are counted, the first step is count 1 (the landing front foot) the second step is count 2 and the ball is passed to the next player in the opposite line before the third step hits the ground.

- Begin this exercise with the groups starting closer together and walking rather than running. This is to get the footwork right.

- Still walking, push the speed.

The players might find walking more difficult to time than running, but it will make them concentrate on landing the front foot as they catch the ball. It will also aid them in getting the stepping action right. When walking they might need to jump a little into each step so only one foot is on the ground at a time

figure 4f.

Once the basics are mastered, the distance for the pass is extended and progresses from a walk to a jog then a run. This drill works on fitness, coordination, passing, running and catching on the front foot. You can have a number of groups going at the same time working a star formation. Two balls are used at the same time crossing in the middle.

figure 4g.

The more skillful the players become the faster the exercise can be. After a while, muscle memory kicks in and it becomes a natural movement for the players and they will do it without thought. This drill acts as a good warm up drill before a game.

Drill 4.9: Footwork - catching on the back foot

Even though I have discouraged catching on the back foot in general play and on the run, there are situations in Netball where it is to be encouraged and utilised. The most obvious being for the goalers. Most of us have seen goalers jump and deliberately ground their back foot to be closer to the goal post. This is a great skill to be learnt particularly for aspiring goalers. Catching and landing on the back foot is a timed jump. The ball is taken while the catcher is in the air and the foot closest to the goal ring is grounded first. Both feet can be landed at the same time to get the same result.

- This drill can be done anywhere on the court where there is enough space.

- This drill is done in pairs, one player is the thrower and one is the catcher.

- The thrower and the catcher start about 3 metres apart facing each other.

- The thrower starts with the ball and stands still.

- The ball is passed at a comfortable catching height allowing the catcher room to jump to take the catch.

- The catcher jumps to catch the ball in the air.

- The catcher splits their legs apart to land.

- The catcher grounds the back foot first.

- The distance between the feet can be stretched as far as comfortable.

- Balance and control are to be emphasised.

- The back or grounded foot stays put.

- The front foot is lifted and placed next to the grounded foot as the player stands up.

- Be careful not to drag the feet as they are brought together.

- The players change from being the catcher to the thrower as the ball is returned.

The main use of this skill is for the goalers. It assists the goaler in getting closer to the goal and creating a better shot opportunity.

Drill 4.10: Footwork - jump and split

Drill 4.9 moved into the goal circle.

- This drill is done in and around the goal circle.
- This drill requires 3 players. A thrower, a catcher and an observer.
- The thrower starts with the ball just outside the goal circle and stands still.
- The catcher starts approximately 1 metre inside the goal circle.
- The observer stands to the side.
- The thrower and the catcher start approximately 1 metre apart.
- The thrower passes the ball to a catcher who jumps off the ground to catch the ball as in drill 4.9.
- The catcher, while in the air, splits their legs wide and lands in a stretch position with the back foot as close to the goal as possible.
- The catcher turns, stands and brings their feet together closer to the goal, keeping the back or grounded foot still.
- The landing must be on the foot closest to the goal or both feet can land at the same time.
- The observer watches and provides feedback regarding the footwork.
- The players rotate their roles.

According to the rules of Netball when both feet are landed at the same time, either foot can be lifted and grounded again. It is important players identify if they have landed on both feet simultaneously or on one foot before the other to avoid a footwork infringement.

Drill 4.11: Footwork - catching on the back foot to get more power

Catching on the back foot can be used to put extra power into a longer pass. Balance and control must be emphasised. Catching on the back foot provides the opportunity to stop, steady and balance if a pass option has not presented.

- This drill can be done anywhere on the court where there is enough space. It requires a running space of approximately 10 metres.
- This drill involves a thrower and a catcher. A line of catchers is formed behind the first catcher.
- The thrower and the catcher start approximately 10 metres apart facing each other.
- The thrower starts with the ball and stands still.
- The catcher runs towards the thrower and jumps to take the pass.
- The catcher lands on the back foot and stops.
- All the catcher's weight is on the back foot when landing.
- The catcher uses their front foot to balance and halt momentum.
- The catcher passes the ball back, transferring the weight to the front foot to get extra power in the pass.
- The catcher then moves to the back of the line.
- Rotate the throwers.

catchers drives - lands on the back foot, stop, balance, pass back to - thrower

figure 4h.

This is the same passing motion as used in an earlier drill where the players are standing still (shoulder pass drill 2.10).

CHAPTER FIVE

Skill Development - Drills 5.1-5.13
The Goal Circle

Drill 5.1: Goal shooting

Aspiring goalers need to do extra work in practice sessions.

- 2 goalers work together in this drill.
- The goalers work in the goal circle with a goal ring.
- The ball starts with the player who will shoot first.
- The goaler starts at a close distance to the goal ring and shoots 10 shots, counting each successful shot from that position, for example 7 out of 10.
- The goaler moves to different positions in the goal circle and shoots another 10 shots.
- The other goaler repeats the process.

Keeping a diary can help players monitor their improvement. Encourage them to stay relaxed but concentrate. Muscle memory plays a big part in effective shooting, so a lot of repetition is recommended. Goalers should participate in all the training drills with the other team members.

Shooting practice should be done separate to the team training. Time could be set aside before or after training, or the goalers can practice at home. If time allows, the coach should work individually with the goalers or appoint an assistant to

figure 5

do so. Practicing goal shooting can be a lonely activity. Whenever possible appoint someone to work with the goalers. This may be an assistant coach, a parent, a volunteer or a friend. This person can encourage, correct technique, rebound and return the ball. This will ensure the shooter stays motivated and the session doesn't go too long. Encourage shooters to set goals in their shooting practice.

Positioning for rebound when shooting

Two goalers should not be on the same side of the ring when a shot is being taken. The player shooting needs to delay the shot until the other goaler gets into position. This way both sides of the ring will always be covered should a shot miss. The goaler should always follow their shot in if the shot is taken from a few metres distance. The goaler should fight to get themselves into the rebound zone before the defender does.

If the defender tries to block the 'follow in' move, the goaler should step around the defender to arrive in the best spot for a possible rebound. Any contact with the defender will be a contact call against the goaler should they run into the defender.

Working in the goal circle

In a game situation, where possible, set up a one-on-one in the goal circle. If either the GA or GS sets up in a one-on-one situation in the goal circle, the other goaler should stay out of their space, unless the second defender gets involved, minimising the space. In this case the second goaler should drive to space and use the support of the WA and C for quick sharp feeds (refer feeding into the circle Drills 5.4–5.12 and running patterns Drill 5.9).

Passes between GA and GS in the circle using the lob pass have been addressed earlier (Drill 3.6). Passing to advantage and passing to space have also been addressed earlier. Space behind needs to be created and used. At times, the defense is skillful and tight which minimises the space the goalers have to move. The goalers need to recognise this and if it becomes crowded in the goal circle, they should keep moving. Different positions in the circle should be mentally marked as positions to run to and back. For example, the GA may make a move to the top of the circle and the GS may drive across the base line close to goal. This is where exercises in quick sharp feeds for those outside the circle are needed (refer feeding into the circle Drills 5.3–5.12).

Drill 5.2: Throwing and catching drills in and around the goal circle

The goaler's preferred position (GPP)
Picture the goal circle as being the right-hand side of a clock face from 1 o'clock to 5 o'clock, 3 o'clock being the middle of the court or the top of the circle. These are the positions used in this drill.

figure 5a

- Mark a spot on the court with tape, chalk, a coin or anything that is not dangerous and can be seen from the circle line. I will refer to this spot as being the goaler's preferred position (GPP). The position should be close to the goal ring, slightly to the side, but not too close to the base line. Think about the position a goaler would choose to shoot from if given the choice. This mark is the focal point for the drill.

The Goal Circle

- Mark the points of the clock around the circle with small witches' hats, cones or the like at 1 o'clock, 2 o'clock, 3 o'clock, 4 o'clock and 5 o'clock. 12 o'clock and 6 o'clock are not required in these drills as they exist on the base line.

- 2 or more players are needed for this drill, a thrower and a catcher.

- The catcher starts at the 5 o'clock position. The thrower starts at the 3 o'clock position.

- The ball starts with the thrower at 3 o'clock.

- The catcher runs (drives) from the 5 o'clock position towards the GPP.

- The pass is to be caught by the catcher on the GPP marked on the court.

- The catcher jumps to take the ball in the air, lands on two feet on the GPP, holds for three seconds to show balance. The thrower has to watch, calculate, execute and time the pass with the needed trajectory.

- There can be a line of catchers at 5 o'clock waiting to take their turn.

- The catcher may then shoot a goal to complete the play but shooting is not the focus of this exercise.

- The thrower does not wait for the catcher to get to the mark. Rather, they time the throw so that the ball and the catcher arrive at the same time on the GPP.

Variations

1. Once everyone has had a turn catching from the 5 o'clock position, the catcher moves to the 4 o'clock position and starts again. The thrower stays at 3 o'clock.

2. The catchers move to 3 o'clock. In this position the goaler will be standing beside the thrower so the trajectory of

the throw will need to change to a lob pass so the ball is not thrown out of court.

3. The catchers move to 2 o'clock.

4. The catchers move to 1 o'clock.

The same thrower is used throughout this drill to allow them to practise and adjust to the different angles and projection required when passing from the different positions. A different pass skill is required when the drive is made from the various positions around the circle. A higher lob is required from 3 o'clock and a more direct flat pass is required from 5 and 1 o'clock. A pass trajectory somewhere in between is required from 2 and 4 o'clock. All players should have a turn at being the thrower as well as participating in the catching and balancing component.

1. The thrower and the catchers change starting positions.

2. Work through the various positions as above for the catchers. The thrower moves to the 5 o'clock position while the catchers rotate through all the other positions as they did before. There are many combinations so this drill will need to be varied over many training sessions.

We have reached the stage where we are combining a number of different skills into the one drill.

Drill 5.3: Feeding in and out of the goal circle

Set the goal circle up the same way as in Drill 5.2 (clockface)

figure 5b

- 6 or more players are needed for this drill, 1 goaler and 5 feeders.
- Position a feeder on every hour mark on the goal circle (five feeders).
- The 6th player is the goaler. The goaler starts inside the goal circle facing the 1 o'clock feeder.
- The goaler in the circle starts with the ball.
- The goaler passes the ball to the feeder at 1 o'clock who feeds it straight back.
- The goaler passes the ball to the feeder at 2 o'clock who feeds it straight back.
- The goaler passes the ball to the feeder at 3 o'clock who feeds it straight back.

- The goaler passes the ball to the feeder at 4 o'clock who feeds it straight back.
- The goaler passes the ball to the feeder at 5 o'clock.
- The feeder at 5 o'clock does not pass the ball directly back to the goaler.
- The feeder at 5 o'clock uses a lob pass directed to land on the GPP marked on the court.
- The goaler anticipates, doubles back and takes the pass in the space behind them on the GPP.

The type of pass used for feeding is a chest pass and the drill is completed with a lob pass to the space behind to the GPP (Drill 3.6). A feed pass is meant to spring back very quickly.

Footwork should be a focus for the person in the circle. Do they stand still as they pass out of the circle? Do they walk around? Do they jog or run? Should they jump into each pass and land on one or both feet? Should they keep both feet grounded and only move when they don't have the ball? All these are options but the players must adhere to the footwork rule. The purpose of the exercise is for them to learn to move in the goal circle. The footwork method may change depending on the speed of the drill. I recommend that players keep both feet on the ground when taking the ball. They can step forward towards the next feeder as learnt in the stepping section. Drills 4.1 – 4.4 explain the footwork rule.

Variations

1. The players rotate positions.
2. The catcher in the circle moves to 1 o'clock and becomes a feeder.
3. The thrower at 5 o'clock takes their place in the circle as the new goaler.
4. All the other players move around one place.

Extension to Drill 5.3

Each time the goaler catches the ball they swivel to face the goal ring as if to shoot, then turn back and continue the drill, passing to the next feeder.

Drill 5.4: Feeding improvised

This drill is set up the same way as Drill 5.3 (clockface).

- 6 or more players are needed for this drill.

- Position a feeder on every hour mark on the goal circle (five feeders).

- The 6th player is the goaler. The goaler starts inside the goal circle.

- The goaler in the circle starts with the ball.

- The goaler chooses which feeder they will pass the ball to.

- The feeders outside the circle don't know who the pass is coming to and need to be ready and alert.

- The goaler may choose to use the same feeder five times, or pass around randomly.

- The passes need to be counted, because as before, the fifth pass back into the circle is a lob pass to space directed to land on the GPP.

- The goaler anticipates, doubles back, takes the pass and lands on the GPP.

- The goaler shoots the goal to complete the drill.

Variation

1. The players rotate positions.

- The catcher in the circle moves to 1 o'clock and becomes a feeder.

- The thrower at 5 o'clock takes their place in the circle.

- All the other players move around one place.

Drill 5.5: Feed and shuffle

- This drill is done anywhere there is space on the court.

- This drill is done in pairs.

- 2 players work together in this drill. A goaler and a feeder.

- The 2 players face each other starting approximately 1 metre apart.

- The ball starts with the goaler.

- The goaler passes the ball to the feeder (feed 1).

- The feeder stands still.

- The goaler, after passing to the feeder, steps, jumps or shuffles backwards and increases the distance between them.

- The feeder then feeds the ball back in, and so on (feed 2).

- This continues until the goaler is in the position they want (feed 3 & 4 etc.).

Feed 4 Feed 3 Feed 2 Feed 1 feeder
goaler steps back after each pass

figure 5c.

Quick, sharp passes and a good understanding between the feeder and the goaler is required. Pass out, step backwards, stand still, pass in, repeat.

- In a game situation the goaler works in tandem with a feeder, usually the C or WA and passes the ball out to the edge of the goal circle.

- The goaler then moves back closer to the goal into the space they have behind them to take a returned pass.

- They may repeat this play to edge in closer to the goal.

- The passes need to be timed so the goaler ensures there is sufficient space behind them to move into.

If a defender has taken up the space directly behind the goaler, and the goaler moves back too fast, the defender may not have time to move back the required distance before the goaler moves back into them. The goaler cannot just push back into a defender. The goaler does not have the benefit of the 0.9 metre distance rule when they are not in possession of the ball. If the goaler passes the ball out of the circle to the feeder and steps back into the defender before the defender has had time to move out of the space, the goaler is making the contact. When the goaler first takes possession of the ball, the defender must immediately attempt to move back the required distance of 0.9 metre before raising their arms to defend. The goaler should retain possession of the ball just long enough for the defender to retreat, then make the pass out to the feeder, shuffle backwards into that space, or jump and stretch their legs wide if they choose to use this technique (Drill 4.6).

Variation

1. Move this drill into the goal circle. The feeder stands just outside the goal circle. The goaler starts about one metre inside the goal circle and works back towards the goal.

Drill 5.6: Moving back using the jumping technique

- This drill can be performed anywhere there is enough space.

- The players work in pairs.

- 2 players are required for this drill. A catcher and a feeder.

- The 2 players start facing each other at about a metre apart.

- The ball starts with the feeder.

- The feeder passes the ball to the catcher.

- The catcher jumps in the air when taking the pass. The catcher stretches their legs wide apart and lands in a type of splits position with the back foot landing first and closer to the goal post (refer to catching on the back foot Drill 4.9).

The footwork rule states the foot that is grounded first (landed on) can be lifted, but not re-grounded. Many players are called for stepping in this situation and don't understand why. It's really simple, the landing foot has been lifted and re-grounded. However, both feet can be grounded at the same time.

Variation

1. Move this drill into the goal circle. The feeder stands just outside the goal circle. The goaler starts about one metre inside the goal circle and works back towards the goal.

Drill 5.7: Pass to feeder and drive

- This drill is done in and around the goal circle.

- A mark is placed on the court to mark the goaler's preferred position (GPP).

- 2 or more players are required for this drill, a goaler and a feeder.

- The feeder stands outside the goal circle at the 1 o'clock position.

- The goaler starts at the 3 o'clock position.

- The goaler starts with the ball.

- The goaler passes the ball to the feeder outside the goal circle at 1 o'clock.

- The goaler runs (drives) to the GPP to receive the pass back.

- The goaler jumps and lands on two feet (Drill 3.4).

- The goaler holds for three seconds to prove balance.

- The goaler shoots the goal.

Variations

1. The GPP is moved to the other side of the goal ring.

2. Repeat the drill with the feeder at the various other clock positions around the circle.

figure 5d

- These drills can be done as a team, each player taking their turn from all positions on the circle.

Fast and furious

Once the idea is grasped add speed, energy and strength.

Drill 5.8: Pass to feeder, cut and drive

- This drill is done in and around the goal circle.

- A mark is placed on the court to mark the goaler's preferred position (GPP).

- 2 or more players are required for this drill, a goaler and a feeder.

- The feeder stands outside the goal circle at the 1 o'clock position.

- The goaler starts at the 3 o'clock position.

1.00 feeder

Running path
Ball path

Goaler's preferred position

Goaler's starting position inside circle

Goaler passes to 1.00 cuts and drives to GPP to take pass back

figure 5e

- The goaler starts with the ball.

- The goaler passes the ball to the feeder outside the goal circle at 1 o'clock.

- The goaler runs (drives) to a different point before turning and driving to the GPP to receive the pass. This is like a baulk.

- The goaler lands on two feet (Drill 3.4).

- The goaler holds for three seconds to prove balance.

- The goaler shoots the goal.

Variations.

1. Move the GPP to the other side of the goal ring.

2. Remove the GPP and allow the goaler to choose their own shooting position.

3. Add a defender to make the goaler work hard for position and teach the feeders to time the pass to suit.

4. Repeat the drill with the feeder at the various other clock positions around the circle.

Drill 5.9: Pattern running in the goal circle

There are two goalers allowed in the goal circle and they need to work together to create space and opportunities for each other. Goalers can sometimes find themselves blocked in or trapped standing still in the goal circle. When this occurs, the feeders can find it difficult to get the ball into them. In this situation the goalers need to run a pattern and keep moving to create more options. The basic running pattern is an in-out pattern. One runs in and one runs out. The goalers need to avoid being caught or trapped together.

- This drill is done in and around the goal circle.
- 4 players are required for this drill, 2 goalers and 2 feeders.
- Mark five positions on the court with tape, chalk, etc. Number them 1 to 5.

1. position 1, approximately 1 metre to the side of the goal ring. (GPP)
2. position 2, approximately 1 metre to the side of the goal ring on the other side. (GPP)
3. position 3, approximately 1 metre outside the circle at 4 o'clock.
4. position 4, approximately half a metre outside the circle at 3 o'clock.
5. position 5, approximately 1 metre inside the circle at 1 o'clock.

- One of the goaler starts on position 1 and the other on position 2 (see figure 5f).
- The feeders are positioned on the circle, one at 2 o'clock and the other at 5 o'clock.
- The feeder at 5 o'clock starts with the ball.

The complete guide to coaching and teaching Netball

```
1.00 feeder 1
        2:00
        feeder2
5
1

2
        3
   5:00
   feeder 1
```

- Ball starts with feeder at 5 o'clock.
- Goaler 1 (GS) starts at position 2.
- Goaler 2 (GA) starts at position 1.
- GS drives out towards feeder at 5 o'clock to accept a pass.
- GA drives out to position 4 to take a pass from GS.
- GA passes out to feeder at 2 o'clock.

Running path →
Ball path →

figure 5f

- The goaler on position 2 drives out towards position 3 and receives a pass from the feeder at 5 o'clock. It doesn't matter if they take the pass inside the goal circle.

- The goaler on position 2 runs out to position 4 and takes a pass from the first goaler.

- The second goaler passes the ball to the feeder outside the goal circle at 1 o'clock.

- The first goaler drives to point 1 (GPP) and takes the pass from the feeder at 1 o'clock.

- The goaler shoots the goal.

In this scenario, the goaler who started on point 1 has to decide where to run next. They have run out to position 4, taken a pass outside the circle, made a pass to the feeder at 2 o'clock and now need to keep moving. They can either run to position 2 to position for a rebound, or position 3 (5 o'clock) to create another pass option should they be needed. Practice all options.

The key to this drill is to keep moving. The goalers may need to run to positions where they do not get the ball. If they do not receive the ball, they continue to run to another position. The goalers need to be alert to where the other goaler is running so not to get in each other's way. This will take time and require understanding between the two goalers.

Variation.

1. Do this drill in reverse. The ball starts with the feeder at 1 o'clock and the ball will end at position 2, the preferred shooting spot on the other side.

Drill 5.10: Improvised running pattern in the goal circle

- This drill is done in and around the goal circle.
- 4 players are required for this drill, 2 goalers and 2 feeders.
- Five positions are marked on the court as per drill 5.9.
- One goaler starts on position 1 and the other on position 2 (see figure 5g).
- The feeders are positioned on the circle, one at 2 o'clock and the other at 5 o'clock.
- The feeder at 5 o'clock starts with the ball.
- The four players pass the ball around and keep it in continuous motion.
- The goalers run out, in and across to the various points.
- The goalers stay on the move all the time.
- The goalers work it so that one of them ends up with the ball under the ring on the goaler's preferred position (GPP).

- 2 goalers
- 2 feeders
- improvise with continuous movement in and out to the various points in the goal circle
- continuous fast passing in and out of the goal circle
- ends with one of the goalers on GPP

figure 5g

Drill 5.11: Improvised running pattern in the goal circle with one defender

This drill is the same as Drill 5.10 with 1 defender included.

- This drill is done in and around the goal circle.
- 5 players are required for this drill, 2 goalers, 2 feeders and 1 defender.
- Five positions are marked on the court as per drill 5.9.
- One goaler starts on position 1 and the other on position 2 (see figure 5g).
- The feeders are positioned on the circle, one at 2 o'clock and the other at 5 o'clock.
- The defender starts anywhere in the goal circle.
- The feeder at 5 o'clock starts with the ball.
- The goalers run to any of the five points marked in the circle.
- The 2 goalers and the 2 feeders keep the ball moving and off the defender.
- The goalers stay on the move all the time.
- The defender tries to get the ball.
- The goalers work the drill so that one of them ends up with the ball under the ring on the goaler's preferred position (GPP).
- This is a game of fast keepings off, 4 versus 1.
- The play ends after about one minute when one of the shooters takes the ball on the GPP. This can be either side of the goal ring.

Variation.

1. The players change roles so all take a turn at feeding, defending and positioning.

Drill 5.12: Improvised running pattern in the goal circle with two defenders

This drill is the same as drill 5.10 & 5.11 with 2 defenders included.

- The 2 goalers and the 2 feeders keep the ball moving and off the defenders.

- The goalers stay on the move all the time.

- The defenders try to get the ball.

- The goalers work the drill so that one of them ends up under the ring with the ball on the goaler's preferred position (GPP).

- This is a game of fast keepings off, 4 versus 2.

- The drill ends after about one minute when one of the shooters takes the ball on the GPP. This can be either side of the goal ring.

Variation.

1. The players change roles so all take a turn at feeding, defending and positioning.

2. Add 2 more defenders to defend the 2 feeders outside the circle.

In these drills there are three outward directions for the goalers to run, 5 o'clock, 3 o'clock and 1 o'clock. There are two inward directions for the goalers to run, position one and position two. The goalers can also run across the circle from 5 o'clock to 1 o'clock, or the reverse (running the base line).

This drill is to get the players into the habit of running. In a game situation the running points cannot be scripted. These are basic movement patterns to teach how to create and use space in the goal circle.

When one of the goalers takes up the 3 o'clock position, they may act as a third feeder for that brief moment. They can pass to the other goaler or to the feeder at 2 or 5 o'clock. If the other goaler is open to receive the pass near the goal ring, then this should be the first option as it is a waste

to pass the ball outside the circle if the other goaler is in good position to goal.

Both goalers need to work together and be aware of the space they have to use. The goalers should not get in each other's way. When one goaler runs out, they create space near the ring for the other goaler to run into. You may have two goalers out at any one time, but avoid having two goalers in unless one of them is shooting.

The goalers may need to run out to space even though there is no pass being made to that space. The goalers need to be constantly aware of an opportunity to drive to the post. The goalers need to keep moving until one of them has the ball in a shooting position.

The bounce pass

Sometimes it may be the best option to use a bounce pass when feeding the ball into the goal circle. If the goaler is cramped and the only space is low and to the side, the feeder may choose to bounce the ball into the space the goaler is protecting with their body positioning. This should be practised as well.

Drill 5.13: Goaler throw-in

When a goaler is taking a throw-in from the base line behind the goal circle, the goaler on the court positions to create and protect space around them. In this scenario the goaler on court is often double teamed so the best option is to pass out to the corners and receive a feed back in.

This drill is done in and around the goal circle.

- 6 players are required for this drill, 2 goalers, 2 feeders and 2 defenders.

- One goaler takes a throw-in from outside the court behind the goal circle.

- The goaler on court positions themselves with as much space around them as possible.

- The goaler on the court positions on the other side of the ring to the goaler taking the throw in. This creates space for the other goaler to run into should they use one of the feeders.

- One feeder positions at 4 o'clock, or 2 o'clock, depending on which side of the court the goaler is taking the throw-in.

- The feeder defends the space in the corner with their body. The other feeder positions at the top of the circle (3 o'clock).

- The two defenders are free to defend in any way they like.

- The ball starts with the goaler taking the throw in.

 1. Option 1. The ball is passed to the goaler on court if they have made good position.

 2. Option 2. The ball is passed to the feeder in the corner (2 or 4 o'clock). The ball is passed to the space (drill 3.8).

 3. Option 3. The ball is passed to the feeder at 3 o'clock.

- The goaler making the throw-in needs to be aware of the space on the court and quickly run into that space once they have put the ball back into play.

- The goaler taking the throw-in runs into the space and receives a quick return pass from the feeder.

- When the goaler on court is trapped or double teamed, they wait patiently. They will become free once the other goaler has returned to the court.

Take this drill step by step and approach it slowly. Work on each pass individually many times before moving on.

1. Practise the pass to and from the feeder at the side.
- Goaler passes to feeder on the side, runs on court and takes the pass back.
2. Practise the pass to the feeder at the top of the circle.
- Goaler passes to feeder on the top of the circle, runs on court and takes the pass back.
3. Practice the pass options to the goaler on the court.
- Lob pass, pass to the side, pass to the front.

- Game simulation. Let the players choose the pass options as in a real game. This drill may turn into the same drill as 5.3 (feeding in and out of the circle).

Variation

1. Add two more defenders to defend the C and the WA outside the circle. The feeders may need to double back around to the top of the circle if they need more space.

2. Repeat the drill starting from the other side of the court.

3. Rotate the players.

- GS passes to one of three options
- feeder at 5 o'clock
- feeder at 3 o'clock or GA
- two defenders work in the circle
- the GS steps on court immediately after making the pass in to receive the feed pass

Running path →
Ball path →

figure 5h

CHAPTER 6

Skill Development - Drills 6.1-6.6

Defense

So far, all the drills and skills we have been working on have been focused on attack. Defense skills and strategies are just as important as attacking skills. Half the game of Netball is attack and half the game of Netball is defense. My observation over the years has revealed that many defenders only see their role as one of defending and many attackers only see their role as one of attacking. The more successful and skillful teams have dynamic attacking defenders as well as energetic, defending attackers.

Netball is a team game:

- When in possession of the ball all players are attackers.

- When the opposition has possession of the ball, all players are defenders.

The focus when defending is to take back possession of the ball and to stop the opposition from scoring. When a team takes possession of the ball from the opposition they should view and celebrate it as if a goal has been scored. Both individual and team defensive skills are to be learnt and developed for all Netball players.

The basic strategy:

- in attack, space is our friend

- in defense, space is the enemy.

When defending, most Netballers get caught up in player chasing and are not conscious of space or any intercept opportunities that may be presented. If space is closed down and limited, it makes it more difficult for the opposition to find a way through, particularly if the players are skilled in the art of interception (drills 7.1 – 7.6).

When defending, one objective is to close down and occupy space. Netball is a game of attack (possess) and defense (dispossess). Netball is a low-level contact sport so players can't tackle or fight to win possession. There are many situations in a game of Netball where one-on-one contests will occur.

Defensive skills are to be learnt, developed and improved to minimise mistakes. Minimise the number of mistakes and defensive errors, and you will minimise the number of goals scored against you.

Drill 6.1: Defending the individual - zoning a player

Zoning the player refers to blocking them from running forward down the court to become the next pass option. When defending a player by zoning, rather than jumping up and down waving arms in front of them, the defender stays grounded and denies the thrower the opportunity to run down the court to accept the next pass. Zoning a player is a skill every Netballer should learn.

Zoning explained

- A defender may stand in the attacker's path and block them from running down the court.

- The defender's stance must be considered a natural standing position.

- A defender must keep their arms down by their sides and only the body can be used to block or zone.

- The attacking player must make an effort to avoid the defender and may get called for contact if they attempt to push through. This is a rare call from umpires but it does and should happen.

- The attacking player can run off court but the defender cannot follow.

- The defender must stay on the court but can block them again when the attacker attempts to return to the court unless it is a free pass in from outside the court.

Rationale for zoning

In a game of Netball, it is common for a player to pass the ball and run forward to accept the next pass. When a defender can distract, slow down and hold up an attacker for three or more seconds, it eliminates that attacker from being the next pass option. One less pass option for the opposition increases the possibility of a turnover. This can force a held ball, a misdirected pass or pressure a player into attempting a risky one. A turnover is worth a goal. A turnover provides another scoring opportunity for your team.

The player implementing a zone focuses on restricting the thrower running on to get the next pass. This may not show as a statistic on the team sheet and the spectators may not notice what has been achieved, but it is a valuable contribution to the team effort.

Drill in zoning the player

- There is no ball used in this drill.

- This drill is done in one third of the court – line to line.

- This drill is done in pairs.

- One player is the attacker, the other is the defender.

- The drill starts at one end of the court and extends to the first transverse line (could go across the court or be done in the centre third).

- The objective for the attacker is to walk from one line on the court to the next line as quickly as possible.

- The objective for the defender is to make it as difficult as they can by blocking their path.

- The defender cannot use their arms to block. The arms are pinned to their sides at all times.

- The defender faces the attacker and allows them 0.9 metre space to start.

- The defender should resist moving backwards as much as possible and make a real effort to stop the attacker getting past them.

- The defender should hold the attacker up as long as possible.

- The defender should accept that contact will be made and where possible position their body so that the attacker is the one making the contact.

figure 6a

Variations

1. Run a number of pairs at the same time.

2. Make it a race or competition.

3. Swap roles.

4. Change pairs.

5. Once the concept is grasped, allow the players to run.

If you are running this drill as a group exercise it can be fun to include it as a race or a competition. The winner will be the defender who has held up the attacking player the longest. All players should have a turn at being the attacker and defender. For training purposes, the attackers should be restricted from going off court, but players should realise that if they are being zoned themselves in a game, a good option of escape is to run off court and back on at a different place. Even if an attacker runs off court to escape the zone, it soaks up time, and nearly always eliminates them from making position quickly enough to present as the next pass option. Objective is achieved. The objective being that this player has been taken out of play as the next pass option.

Introduce zoning into a game

"This week we are not going to focus on defending the ball, rather we are all going to defend the player". This does not apply to defending the goalers when shooting. Staying grounded and zoning is sometimes a better option than jumping up and down on the spot in an opposition

player's face, which really achieves little. Once the defender has left the ground the attacker has the advantage and can run on easily. An attacking player cannot just run through a defender. This is one part of the game that has contributed to Netball being rebranded from a non-contact sport to a low-contact sport.

Unwanted contact

This style of defending may result in some players being knocked or pushed off their feet. Teach the players to expect some contact and brace themselves for it. Remember, as soon as the zoning player extends arms across the attacker or uses their arms to block the path, a contact call should be made against them. No arms, only body and shoulders are to be used. Watch the players as they practice to ensure correct technique.

Some umpires may interpret this method of defending as 'forcing a contact', but it is within the rules for a defender to block the path of an attacking player who does not have the ball. As in a lot of sports, players need to play and adapt to the umpires' interpretations. Forcing a contact is generally called if a defender deliberately steps into the path of an attacker who is in 'mid-air', as they must be given space to land. If uncertain, invite an experienced umpire to training and seek clarification.

Zoning can be used in other situations in Netball. Zoning an opposition player to allow a teammate to get clear is beneficial and a strategic part of the game (see set plays Chapter 9).

Drill 6.2: One-on-one defending

There isn't a lot that can be done when the opposition is in possession of the ball. The opposition has the space and all the advantages that go with being in possession. The defending side is waiting and hopefully pressuring the opposition into making a mistake. This may be a misdirected pass, a fumble, a dropped catch, a stepping violation, a held ball or it may be presented as an intercept opportunity. When defending, pressure is to be applied to increase the chances of the opposition making mistakes.

One on one defending - defending the ball

Defending the thrower - hands over the ball.

A player defending the thrower rarely intercepts the ball successfully. However, defending the player passing the ball can put them under enough pressure to cause a mistake. Defenders should not raise their arms until the required distance of 0.9 metre has been taken. Often a player will run in front of an opposition player who has the ball, waving their arms before establishing the required distance, particularly when coming from the side or behind. Distance first, then arms. I like to teach players to be generous in taking their distance to avoid obstructing.

When defending in this manner, one arm is stretched up high and the other arm follows the ball or is stretched to the side. Make sure the defender does not touch the ball while still in the hands of the thrower. Placing the hand over or in front the ball is to be practiced and mastered. The choice of which arm to reach up and which arm to use to follow the ball often will depend on the position on the court the player is passing from. If near a side line there is no value in defending the space outside the court. Therefore, the arm that is kept lower, the one that follows the ball, will be to the court side. Arms can be swapped at any time. Practicing this on both sides of the court will assist the players to adapt and learn this concept. The positioning of the arms can influence the type of pass the opposition player will make. When defending with arms held high the opposition player is more likely to throw the pass higher which increases the opportunity of an intercept. Moving the arms with energy places more pressure on the thrower. Players who master this skill place a lot of pressure on the opposition. Remember, distance first then arms.

- This drill does not require a lot of space and therefore a number of groups can operate at the same time.

- Players form groups of 3, 2 thrower/catchers and 1 defender.

- The 2 thrower/catchers stand still and pass the ball between them at a distance of approximately 4 metres.

- The defender stands between the throwers and defends each pass.

- The defender defends with 2 hands, one up high, one hand over and following the ball. The hands can be swapped.

- For the drill, the throwers wait for the defender to get in position before they make the pass.

- The defender should be careful not to place their hands on the ball while the thrower is holding it. However, placing the hand over or in front of the ball, causing the opposition to contact you with the ball is acceptable.

- Once the pass has been made the defender turns around and defends the other thrower.

- You choose the number of passes each player defends.

Defending the thrower – hands over the ball.

figure 6b

Variations

1. Rotate the roles so all players take a turn at defending.

2. **Add a second defender** to defend the one thrower and gauge the impact of double teaming.

Some teams have very tall goalers who position themselves under the ring and rarely move. The team feeds them with high passes which are nearly impossible to defend. **Double teaming** the thrower can cause the pass to be mistimed or misdirected. When pressure is placed on the thrower by crowding and blocking their vision, they do not get an easy pass. This may not work every time, but even one or two turnovers makes the effort and strategy worthwhile.

I once observed a game in which this scenario played out. It was in a carnival played over a week. The GS was nearly half a metre taller than the GK. The GS rarely moved from the GPP. The ball was passed in high every time. The GK had no chance. The second time these teams met the opposition strategy was to double team and put more pressure on the thrower. What this did was to cause a number of passes to be misdirected or fall short of the mark. This put the defenders back in the game and a different result was seen.

Drill 6.3: One-on-one defending - batting the ball away

- This drill requires one third of a Netball court.

- There can three or more players in this drill. A thrower, a catcher and a defender. The other players form a line behind the first defender.

- The thrower and the catcher are positioned approximately three to five metres apart.

- The other players form a line behind the first defender, to the side of the catcher, one behind the other (see figure 6c).

- The first person in the line is the first defender. The next will be the second defender etc.

- The first defender will become the next thrower. There is one thrower waiting at all times.

figure 6c

- Use two balls to keep the drill moving quickly. While one defender is retrieving the ball they have batted away the next defender can step up to defend the catcher now using the second ball.

- The thrower starts with the ball and throws directly to the catcher who is being defended. The first thrower stays for two throws before rotating.

- The defender positions themself close beside the catcher, bouncing on their toes with some energy and aggression.

- The defender stands side on facing the catcher and slightly behind but watching the thrower.

- The defender is to get as close to the catcher as possible without making contact.

- The defender starts from a position that allows them to lunge forward.

- When the pass is made, the defender lunges forward batting the ball away before it gets into the hands of the catcher.

- The defender uses their outside arm to bat the ball away. This minimises the chance of making contact with the attacker, but does not eliminate it. The outside arm is the arm furthest away from the catcher.

- The defender avoids batting the ball directly back to the thrower.

- The defender bats the ball away to the side and chases after it.

- The defender keeps the ball and waits to become the next thrower, and the drill continues.

- The previous thrower moves to the back of the line.

Variations

1. The drill is repeated using the other arm on the other side.

2. The players rotate roles throughout so everyone gets a go.

In practice sessions it is quicker for the defender to hit the ball back to the thrower to save time. Habits formed in rehearsal come out in performance and we don't want a defender in a game hitting the ball straight back to the thrower. I recommend batting the ball away to the side and chasing it.

Bouncing on the spot with energy is recommended for the defender as it aids reflexes, prompts a quick reaction, as well as possibly unnerving the catcher (a little psychology). This skill is to be developed on both sides of the body, always batting the ball with the outside arm and following it up to take possession. This skill is best employed in a game situation where the opposition is passing the ball short distances. Anticipation, sharp reflexes and timing can provide many a turnover. There are other variations of this drill that can be adapted to suit your needs, time and team.

Defending in the goal circle

The GK and GD need to work together and have a good understanding of each other's role. Crowding the circle and occupying space is to be encouraged. This means the two defenders stay back close to the ring, one on each side occupying the goaler's preferred positions.

Allow the opposition GA and the GS to move out of the circle freely without chasing them in general play. This does not apply to centre passes or when the ball is down the other end of the court. When the ball is being passed around by the opposition in their goal third, both defenders stay back in the goal circle taking space, crowding the goaler and keeping a lookout for intercept opportunities. Passes are often made by the opposition to the pockets which present opportunities if the GK and the GD are on the ball. This means leaving the circle and the goaler to get the ball. More about this when we look at the interception drills and skills.

If a defender gives up space in the goal circle, space is left open for the opposition goalers to run to. The GD and the GK need to develop good judgment when leaving the circle. The defenders need to be aware of the goaler returning to the circle, anticipate and watch for an intercept opportunity. Refer to the previous drill (lunging in front, batting the ball away and following it up drill 6.3 one on one defending).

When the defenders stay back in the goal circle, with only one goaler in the circle, one defender takes the front and the other takes the back position. The defenders stay as close to the goaler as possible. There is no rule for space when a player doesn't have the ball. Minimising room and

the space a goaler has to move in is a great defensive strategy. Defenders need to stay alert, always on their toes and ready to make a play for a possible intercept. Both defenders need to be aware of the other goaler driving back into the circle. The side of the circle the free goaler drives into will determine which defender will be presented with a possible intercept opportunity. Think intercept, watch, set and go for it.

WD and C's role in defending the circle

The WD and the C have duel defensive roles. The opposition goalers will be looking to their WA and C to provide support and feeds from around the goal circle. In every case the feeders need to be pressured, even if a contact, obstruction or offside infringement is called against them. There should be no easy free passes into the goal circle. If the opportunity presents, they should force them as far into the pockets as possible minimising the space they have to work and move in.

If the opposition GS or GA are outside the goal circle the WD and C should make it difficult for them to get in (zoning drill 6.1).

In Netball only two players can score a goal and they can only score a goal from inside the goal circle. If they can't get into the goal circle they can't score. It is impossible to keep the GS or GA outside the goal circle for long periods of time. However, sometimes it only requires a goaler to be held up for a few seconds or become distracted by avoiding a defender, for a turnover opportunity to be created. The WD and the C should make zoning the GA or GS out of the circle a priority when the opportunity presents. The focus is to hold them up and delay them as long as possible. The WD and the C are to forget about the opposition WA and C in those moments. The WA and the C players cannot score goals. Once both goalers are inside the circle the focus returns to defending the direct opponents.

Intercept opportunity

In this scenario the GD and the GK should be aware that the WD or C have left their direct opponents to zone, so the opposition WA and C are open to receive a pass. This may present a possible intercept opportunity to the GK or GD if they have setup and are ready to pounce. The defender in the circle who has taken the front position keeps an eye on the free WA or attacking C who may setup to receive a pass into the corner (pocket) on the circle. A quick lunge forward can result in an intercept.

Drill 6.4: Defending a shot - boxing out

- This drill is done in the goal circle.

- This drill requires 2 players, a goaler and a defender.

- The goaler sets up to shoot a goal at a distance of approximately 2 metres.

- The defender sets up to defend the shot at the legal distance (0.9m). Better to be too far than too close.

- The defender keeps both feet firmly on the ground and balances. They do not jump.

- The defender stretches straight up as high as possible. Stretching with one arm will generally allow for a little extra height.

- As soon as the ball leaves the goalers hand the defender pulls the defending arm down quickly.

- The defender then steps forward into the space between themselves and the goaler as quickly as possible. The defender quickly twists around to face the goal post, anticipating a rebound in that direction.

- The defender positions their body to block the goaler from running into that space and getting the rebound should the ball rebound that way.

figure 6d

It is important that the defender pulls the defending arm down quickly or they will be called for obstruction. If the space is secured quickly and the goaler runs into or jumps over the defender, the goaler is making the contact. Exceptional defenders with great athletic ability can sometimes jump and hit the ball away once it has left the goaler's hand, but this is rare even for the most skilled and experienced Netball defenders.

Jumping puts the defender off balance and out of position to rebound. Do not jump. If jumping when defending a shot, the defender will most likely jump into the restricted space, be put out of play and another shot awarded.

There are five possible outcomes when a goaler is shooting for a goal:

- the ball goes through the ring and a goal is scored
- the ball hits the ring and rebounds out of court
- the ball hits the ring and rebounds back in the direction of the goaler
- the ball hits the ring and rebounds to the far side of the ring
- The ball hits the front of the ring and rebounds towards the centre.

Jumping up and down on the spot when defending a shot rarely achieves anything and often causes the defender to encroach on the 0.9m obstruction rule.

This boxing out action should be practiced over and over again. All players on the team should know and learn this skill as they never know when and if they may be called to play in the defense positions. Players can also encourage and remind the defenders in a game what they need to do e.g. box out, one each side, etc. Old habits take time to break and new ones take time to form. Be patient.

Drill 6.5: Defending a shot - positioning for rebound

- This drill is done in the goal circle.

- This drill requires 4 players, 2 goalers and 2 defenders. Both goalers take turns at shooting for goal from a distance of approximately 3 metres. Better to use players who are not goalers to maximise the number of rebound opportunities presented. However, all players should have a turn.

- The defenders position, one either side of the goal ring, protecting the drop zones.

- The defender, defending the shot, practices the boxing out skills as described above 6.4.

- The defender, defending the other side of the ring, positions their body to keep the other goaler out of the drop zone.

- The other players stand to the side observing and waiting their turn. Observing aids learning for when it is their turn.

- Each goaler attempts 5 or more shots before rotating.

Drill 6.6: Defending a shot – and a pass

- This drill is done in the goal circle.

- This drill requires 4 players, 2 goalers and 2 defenders. Both goalers take turns at shooting for goal from approximately 3 metres. **In this drill the goalers have the added advantage of passing to the other goaler as well as shooting.**

- The defenders position, one on either side of the goal post, protecting the drop zones.

- The defender defending the shot practices the boxing out skills as described above (drill 6.4).

- The defender on the far side of the ring positions their body to keep the non-shooting goaler out of the rebound zone. This increases the chances of securing the rebound if the ball rebounds to that side.

- The defender on the far side of the ring also needs to be alert to a possible quick pass between the goalers. This presents an intercept opportunity if the defender is alert.

- The other players stand to the side observing and waiting their turn. Observing aids learning for when it is their turn.

- Each goaler attempts 5 shots before rotating.

When a shot misses, a rebound opportunity is likely presented. These rebound opportunities can present on both sides of the ring. The defenders should avoid defending on the same side of the ring when a shot is being taken. When these positions are secured by the defenders, it is most likely that any rebound will be secured as well. Securing this front position also increases the likelihood of the attacker making contact should they contest the rebound.

CHAPTER 7

Skill Development - Drills 7.1-7.6
Intercepting

Defending space

When a defender is not defending the thrower, the player moves back down the court far enough to read the play and set themselves for an intercept opportunity (defending space). When defending space and not defending the thrower, the opposition has less space to use down the court and this has the potential to provide intercept opportunities. When a defender does not defend the throw and positions themselves strategically on the court, they have a better view of the game, to whom and to where the opposition is looking to pass the ball. Like a game of chess, watch, think and plan ahead.

A scenario

The opposition GK has a base line throw-in. The GS can either defend the thrower on the line, or they can move back to the transverse line in the middle of the court and observe what is unfolding. They are watching, thinking, planning and setting themself for a possible intercept. The opportunity may present or it may not (drill 7.3).

Which of these 2 defensive positions has the most potential to create a turnover opportunity? There are many, many intercept opportunities provided in a game of Netball that go unidentified. Any medium to long pass that hangs in the air should be seen as an intercept opportunity. Allowing the opposition freedom to pass the ball around uncontested in their defensive third is to be encouraged. Once a ball is in the air for a period of time an intercept opportunity is presented.

Returning to the scenario

The WA, GA and C have positioned to fill space in the centre third (team zone drill 8.1). The opposition GK makes a safe pass to an uncontested GD in the defensive third. The GD sees the WD standing unguarded on the

opposite side of the court and launches into what they consider to be a safe pass. The GS, who has positioned themselves back on the transverse line, has been watching all this unfold and is anticipating this pass. The GS moves forward, cuts across the pass and makes a clean intercept (drill 7.3)

This is a scripted scenario and it may not play out this way, but it may. It definitely won't if players are not taught to think, read the game and have the skills to set themselves up to make intercepts. What is more often observed in this scenario is the GS defending the GK on the base line, the GA chasing the GD around in circles, the C and the WD chasing their opponents wondering where the ball is. It should be obvious now that there are different ways of seeing the game of Netball and how it can be played.

Intercepting is the most underdeveloped and ignored skill in the game of Netball.

The rules of Netball favour and provide great advantages to the team in possession of the ball. It is a wonder that more attention has not been paid to developing and implementing the skills of interception. The ball is never more accessible to the defending side than when it is flying freely through the air.

There are four important aspects to teaching the skills of interception:

- identifying an intercept opportunity
- getting into the right position
- setting for the intercept
- making the intercept.

I have spent hours observing Netball specifically to identify intercept opportunities. At times I am sure I have been the only person to see them. The ball goes sailing through the air covering considerable distance. The ball seems to hang in the air for an insurmountable amount of time. The ball is there for the stealing, but rarely is it stolen. Interception is the most logical way of taking the ball from the opposition. The players cannot wrestle or fight for possession of the ball, so the players either apply pressure to force an error or they wait for the opposition to make a mistake. In theory every pass presents an intercept opportunity. In reality

this is not the case as there is a lot of speed in the game, only seven players of each team on the court and a lot of space to cover.

When I have observed these intercept opportunities, I have looked to see why the ball was not intercepted. What I have mostly observed is defenders chasing their opponents around the court. The players are player focused and not ball focused. The players were unaware that an intercept opportunity was presented and in that brief moment the opportunity had come and gone. However, there are situations in a game where being player focused is important, particularly when zoning. The most exciting and practical way to take possession of the ball from the opposition is to develop the skills and awareness of interception.

Occasionally you might see a dynamic defender who has learnt to read the play well who will orchestrate an exciting intercept. Players who intercept regularly, do not always chase players. Players who intercept well run back quickly and get into a position where they can read the play. Players who intercept set themselves and then launch. When a player sets themselves, comes against the flow of play and flies through the air to make an unexpected intercept, it is as exciting and spectacular as anything you might see in any sport. We don't see enough of it.

Interception is a defensive skill that turns defense immediately into attack. Unfortunately, when some intercepts are made, the interceptor is not always well balanced and gives the ball straight back to the opposition. Balance and control need to be practiced over and over again at training.

The four aspects of interception I have mentioned above:

- identifying an intercept opportunity
- getting into the right position
- setting for the intercept
- making the intercept. The last three are of no value without the first.

An intercept cannot be made without the players learning to identify the opportunities presented. This needs to be taught. A good amount of theory and awareness training needs to be done before good interception skills can be achieved and implemented in a game. Interception is fun to learn and provides a lot of fun in training.

Teaching how to identify an intercept opportunity

The players begin first with the basic and most simple intercept drill (drill 7.1). Once players have grasped the basic idea of what is required, get them to observe others playing Netball. Get the players to watch and identify every potential intercept opportunity. Get the players to think and consider where would they need to be positioned to make that intercept.

This is the beginning of intercept awareness. You may get the team to watch a video, or stay as a team and watch the next game. The team may watch another group doing game drills at training.

Drill 7.1: Intercept basic – getting started

Imagine a group skipping. Two people holding the ends of a rope and turning it. Those skipping have formed a line to the side of one of the rope turners ready to run through the middle on an angle. The skippers run in, jump once and run out the other side. The skippers run around the other rope turner and form a line waiting for all the others to have their turn. Once all have been through, they go again from the new position. This intercept drill follows the same pattern.

- This drill requires only a small section of court space and can be easily done in one third.

- This drill requires a minimum of 3 players but many more can be used as interceptors. 2 thrower/catchers and 1 interceptor.

- The 2 thrower/catchers stand approximately 5 metres apart facing each other.

figure 7a

Intercepting

- The thrower/catchers continuously pass the ball back and forth between them.

- The ball starts with either of the thrower/catchers.

- The thrower/catchers do not wait for the interceptors to be ready.

- The interceptor starts approximately 3 metres to one side of the catcher.

- The interceptor watches the thrower.

- The interceptor times their run across and intercepts the ball.

- The interceptor jumps into the ball and lands balanced using the correct footwork.

- The interceptor holds and balances for three seconds before passing the ball back to the thrower.

- The first interceptor goes around and starts a new line at the other end.

- The next interceptor in the line steps forward, waits for a few passes to go, sets and intercepts.

The next interceptor in the line waits until at least the second throw, (could be more if they need more time to set themselves and get the timing right) before they go. This is about setting, timing and balance. The interceptor needs to be still before they start. Get set and go.

Drill 7.2: Intercept - reading the thrower

An important part of learning to intercept is to learn how to read the thrower. Watching the thrower's eyes to see where they are looking provides some clue to where they may be thinking of passing the ball. I prefer to get the interceptor to watch the ball in the hands of the thrower and follow the arm movements. Some experienced Netballers are very good at looking one way and throwing in a different direction. The ball is the object when intercepting. Watch and follow the ball.

- Four players are required for this drill, 1 thrower, 2 catchers and 1 interceptor.

- The 2 catchers form a triangle shape with the thrower. Point 1 is a catcher, point 2 is the thrower and point 3 is the other catcher.

- The thrower and the catchers stand about 3 metres apart forming an equilateral triangle shape.

ball path →
running path →

Point 2 throws to either point 1 or 3

Point 1 catcher **Point 3 catcher**

interceptor

Point 2 throws to either point 1 or 3, interceptor watches the ball and goes for the intercept on either side.

figure 7b

Intercepting

- the thrower on point 2 starts with the ball.

- The player on point 2 passes the ball to either point 1 or point 3.

- Point 1 and 3 always pass the ball back to point 2 to reset the drill.

- The interceptor starts between point 1 and point 3 in the centre and a little behind the catchers (see figure 7b)

- The interceptor focuses on the ball in the hands of the thrower at point 2.

- The thrower on point 2 does not rush into a pass.

- The interceptor does not know where the thrower will pass.

- The interceptor reads the pass and attempts to intercept.

- The interceptor lands with correct footwork (stands still for three seconds).

- The interceptor should attempt approximately 5 or more intercepts before the next player rotation.

Variations

1. The interceptor takes a step forward and starts closer to the catchers. The triangle stays the same.

2. The interceptor takes another step forward and sets up closer inside the triangle.

3. The interceptor continues to take a step forward until it is not possible to make the intercept.

ball path →
running path →

Point 2 throws to either point 1 or 3

Point 1 catcher **Point 3** catcher
 interceptor

Point 2 throws to either point 1 or 3, interceptor watches the ball and goes for the intercept on either side.

figure 7c

7.2 reversed

1. The interceptor takes a step backwards and starts further behind the catchers. The triangle stays the same.

2. The interceptor takes another step backwards and sets up even further behind the catchers.

3. The interceptor continues to take a step backwards until it is not possible to make the intercept.

➲ Repeat the exercise at a greater distance by enlarging the triangle.

This drill helps the interceptor learn timing, where to set-up and to gauge the distance they need to make a successful intercept. The interceptor has to decide in a split second if they can get to the ball or if they can't. Practicing at these varied distances will assist them in learning this.

The interceptor should not attempt an intercept unless they are confident that they can get to the ball. If the Interceptor mis-times the run and does not make the intercept, they leave a big hole in the defense behind them.

It is advised to keep the passes relatively easy in the beginning so the interceptors can grasp the idea and experience some success. Another way of creating an intercept opportunity is to make it look like the catcher is unmarked. The interceptor should stay still watching the ball, but be aware where the catcher is out of the corner of their eye.

Drill 7.3: Goal shooter interception

Playing specific positions in Netball present opportunities to execute intercepts. These opportunities need to be identified and the skills learnt and practiced.

- This drill requires the entire area of the goal third.

- Four or more players are required for this drill. 1 thrower, 2 catchers and 1 interceptor. You can include a line of interceptors to take turns to keep the drill moving quicker.

- The thrower and the catchers form a triangle (see Figure 7d)

figure 7d

Intercepting

- The first catcher (point 1) is positioned in the goal third approximately 2 metres inside the transverse line and 2 metres in from the side of the court (see figure 7d).

- The other catcher (point 3) is positioned the same on the other side of the court.

- The thrower (point 2) is positioned in the middle of the court at the top of the goal circle.

- The interceptor (GS) positions in the middle of the court just inside the transverse line.

- The thrower on point 2 starts with the ball.

- The thrower passes the ball to point 1 to begin with.

- The interceptor sets and focuses on the ball in the hands of the player at point 2.

- The interceptor reads the pass and initiates an intercept.

- The interceptor lands with the correct footwork and balanced.

- The interceptor returns the ball to the thrower on point 2 and goes to the back of the line.

- The next interceptor in the line steps forward and repeats the drill.

- The drill is repeated on the other side of the court. Point 2 passes to point 3.

Variations

1. The thrower on point 2 chooses where they will pass the ball. It can go either side to point 1 or point 3. The interceptor has to read which side of the court the ball is going and adapt accordingly.

2. Change starting position. Draw an imaginary line across the court touching the top of the circle. The thrower on point 2 takes two steps to the right and the drill is repeated from there. (See figure 7e).

3. Move the thrower (point 2) to the other side of the court and repeat the drill from there. Points 1 and 3 do not move.

4. Move the thrower (point 2) to outside the base line as if for a throw in. Repeat the drill from there.

→ The setting position for the interceptor (GS) does not move away from the transverse line but may move to either side.

→ The GS (interceptor) watches the ball, reads the play and goes for the intercept.

Point 2 throws to either point 1 or 3

figure 7e

There are positions on the court where an intercept is not possible and the interceptor has to read the play and wait. For example, point 2 may take a side court throw-in and pass to point 3. This is a difficult intercept from where the GS is positioned. However, point 2 may decide to pass across the court to point 1 which provides the perfect opportunity.

For a base line throw-in, the GS should set-up in this defensive position so both sides of the court can be covered. Setting up in this position assists the GS to think 'intercept' and become aware of what might unfold. Intercept opportunities may not always occur but you only need a few to make it worthwhile.

Drill 7.4: Goal defense interception

The skills of intercepting as outlined above can be moved to different positions on the court. I have used the same set up below and assigned them to different player positions.

- This drill requires half the court.

- Four or more players are required for this drill. 1 thrower, 2 catchers and 1 interceptor. You can include a line of interceptors to take turns to keep the drill moving quicker.

- The thrower and the catchers form a triangle. (See figure 7f).

- The catcher (point 1) is positioned in the goal third approximately 5 metres inside the transverse line and 2 metres in from the side of the court.

- The second catcher (point 3) is positioned the same on the other side of the court.

- The thrower (point 2) is positioned in the centre circle.

- The interceptor (GD) positions or sets up just outside at the top of the goal circle.

- The thrower at point 2 starts with the ball.

- The thrower passes the ball from points 2 to point 1 to begin with.

- The interceptor sets and focuses on the ball in the hands of the player at point 2.

- The interceptor reads the pass and initiates the intercept.

- The interceptor lands using the correct footwork and balanced.

- The interceptor returns the ball to the thrower on point 2 and goes to the back of the line.

Intercepting

[Diagram showing a netball court with Point 3 (top left), GD interceptor and another player on the left third, Point 2 in the centre circle, and Point 1 (bottom left). Arrows show ball path and running path.]

Ball path ──────▶
Running path ──────▶

figure 7f

- The next interceptor in the line steps forward and repeats the drill.

- This drill is repeated on the other side of the court. Point 2 passes to point 3.

Variations

1. The player at point 2 chooses where they will pass the ball. It can go either side to point 1 or point 3. The interceptor has to read which side of the court the ball is going and adapt accordingly.

2. Change starting position. Draw an imaginary line across the centre of the court passing through the centre circle. The thrower at point 2 takes two steps to the right and the drill is repeated from there. (See figure 7g).

133

3. Move the thrower (point 2) to the other side of the court and repeat the drill from there. Points 1 and 3 do not move.

The setting position for the interceptor (GD) does not move away from the top of the goal circle but may move to either side.

The interceptor (GD) watches the ball, reads the play and goes for the intercept.

figure 7g

Drill 7.5: Goal keeper interception 1

- This drill requires two thirds of the court.

- Five or more players are required for this drill. 1 thrower, 2 catchers, 1 interceptor (GK) and an opposition GS. You can include a line of interceptors to take turns to keep the drill moving quicker.

- The thrower and the catchers form a triangle (see figure 7h).

- The catcher (point 1) is positioned in the goal third in the corner approximately 2 metres in from the end of the court and half way between the goal circle and the side of the court.

- The second catcher (point 3) is positioned the same on the other side of the court.

- The thrower (point 2) is positioned in the centre third just inside the transverse line in the middle of the court.

- The interceptor (GK) positions or sets up inside the goal circle approximately 2 metres in from the base line.

- The interceptor (GK) stands in front of the opposition GS using their body to block the GS from driving out.

- The thrower on point 2 starts with the ball.

- The thrower (point 2) passes the ball to point 1 to begin with.

- The opposition GS is positioned in the goal ring for the GK to defend in case a pass is directed to them.

- The interceptor (GK) has two roles. Defend the GS and make an intercept.

- The interceptor (GK) sets for the intercept and focuses on the ball in the hands of the player at point 2.

figure 7h

- The interceptor (GK) reads the pass, leaves the GS, runs out and initiates the intercept.

- The interceptor (GK) lands using the correct footwork and balanced.

- The interceptor (GK) returns the ball to the thrower on point 2 and goes to the back of the line.

- The next interceptor in the line steps forward and repeats the drill.

- This drill is repeated on the other side of the court. Point 2 passes to point 3.

Variations

1. The thrower (point 2) chooses to throw to one of the 3 options, the GS in the goal circle, point 1 or 3 at the sides.

2. Move the starting position. The thrower on point 2 takes two steps to the right or left and the drill is repeated from there. Points 1 and 3 do not move. The setting position requires the GK to adjust a little depending on where the pass is being made from.

The interceptor (GK) needs to develop very good judgment when orchestrating this interception. If the GK does not get to the ball in time to make the intercept the GS is left wide open undefended under the goal ring. By doing this drill at training the players will learn their capabilities and develop judgement and timing. Encourage bigger risks at training than in games. If a player makes an attempt but doesn't make the intercept, praise the effort.

Drill 7.6: Goal keeper interception 2

- This drill requires two thirds of the court.

- Four or more players are required for this drill. 1 thrower, 2 catchers, 1 interceptor (GK). You can include a line of interceptors to take turns to keep the drill moving quicker.

- The thrower and the catchers form a triangle (see figure 7i).

- The catcher (point 1) is positioned in the defensive goal third approximately half way between the transverse line and the end of the court on the side (see figure 7i).

- The other catcher (point 3) is positioned the same on the other side of the court.

- The thrower (point 2) is positioned in the centre third about one metre inside the defensive transverse line in the middle of the court.

- The thrower at point 2 starts with the ball.

- This is a long pass.

- The thrower (point 2) passes the ball to point 1 to begin with.

- The interceptor (GK) positions and sets up just outside the goal circle.

- The interceptor (GK) sets for the intercept and focuses on the ball in the hands of the thrower at point 2.

- The interceptor (GK) reads the pass and initiates the intercept.

- The interceptor (GK) lands using the correct footwork and balanced.

- The interceptor (GK) returns the ball to the thrower on point 2 and goes to the back of the line.

Intercepting

- The next interceptor in the line steps forward and repeats the drill.

- This drill is repeated on the other side of the court. Point 2 passes to point 3.

figure 7i

Variations

1. The player on point 2 chooses to throw to either point 1 or point 3.

2. Move the starting position. The thrower on point 2 takes two steps to the right or left and the drill is repeated from there. Points 1 and 3 do not move. The setting position requires the GK to adjust a little depending on where the pass is being made from.

CHAPTER 8

Team Defense

When interception skills are developed to a reasonable level, team defense can be introduced. Team defense is all about defending space not players. Team defense is best used when the opposition has a throw-in from the base line or in their defensive third. This allows time for all players to move into their designated position.

Drill 8.1: Centre court press or team zone

Zone interception stage 1. The GS.

This drill requires the whole court. This drill is introduced in 3 stages for simplicity.

- Stage 1 requires a minimum of 10 players. 7 players form the team zone and 3 players are used as opposition.

- The zoning players take their position according to figure 8a.

- The ball starts with one of the opposition players taking a throw-in from the base line or somewhere deep in the defensive third.

- The 3 opposition players pass the ball around and attempt to get the ball through the zone.

- The players forming the zone in the centre court area read the play and set for an intercept but don't get involved in stage 1.

- In stage one we need the GS involved. Stage 1 is to assist the GS to learn and understand what they are looking for. The GS is the first line of defense. Instruct the opposition

players to make some long passes across the court in the defensive third. This allows the GS to get into the action.

- The GS has set up on the transverse line and is waiting for the opposition to make a pass across the court (drill 7.3). The GS's area covers a radius in the goal third.

Full court zone defence

figure 8a

Ball direction

Zone interception stage 2 - The GK.

- This drill requires the whole court.

- Stage 2 requires a minimum of 10 players. 7 players form the team zone and 3 opposition players, 1 thrower and 2 catchers are required.

- The zoning players take their position according to figure 8a.

- The thrower is positioned just inside the defensive transverse line in the centre third.

- The ball starts with the thrower.

- The 2 catchers are positioned in the goal third, one each side of the court.

- The players forming the zone in the centre court area read the play and set for an intercept but don't get involved in stage 2.

- The thrower passes the ball over the zone to either of the catchers. This is a long high throw.

- The GK sets up just outside the goal circle waiting and watching for the thrower to pass over the zone (drill 7.5 and 7.6). The GK's area covers a radius in the defensive third. The GK is the third line of defense. Stage 2 is included so the GK gets an opportunity to see what might happen, knows what to look for and what to do.

- The interceptor (GK) reads the long pass and initiates the intercept.

Zone interception stage 3. The whole team.

- This drill requires the whole court.

- Stage 3 requires a minimum of 10 players. 7 players form the team zone and 3 or more are used as opposition to pass the ball down the court through the zone.

- The zoning players take their position according to figure 8a.

- The centre third is divided into four equal parts and is the second line of defense. Most intercepts will be made here.

1. The GA, WA, C, GD and WD form a star like pattern in the centre third (refer figure 8a)
2. The GD and the WD take the back sections, one on either side of the court.
3. The GA and the WA take the front sections, one on either side of the court.
4. The C positions in the centre circle and has a space to defend that encroaches into the other four areas.
5. All the players position themselves in the middle of their assigned area.

- The ball starts with one of the opposition players taking a throw-in from the base line or somewhere deep in the defensive third.

- The opposition pass the ball around between them and attempt to get the ball through the zone from one end of the court to the other.

- The players forming the zone read the play and set and go for an intercept within their assigned area.

Variation.
1. Vary the starting position for the throw-in in the defensive third.

When a zone is called all players are to:
- get to their positions quickly, stand and hold
- be alert and ready
- avoid shuffling or walking backwards once they are in position
- set and make a play for any presented intercept opportunity in their area.

The team captain may make the call to zone, or it might be done every time the opposition team has a throw-in, in their defensive third. The captain may call "team zone" to instruct all the players to form the zone. The skill needed to implement an intercept in the centre third has been taught in drill 7.2. Intercepts made in the centre third are made at fairly close range so it is important that drill 7.2 is practiced at close distances. The interceptors do not move out of their assigned space until the ball has moved past them.

IMPORTANT NOTE Do not move backwards. It is impossible to initiate an intercept when the interceptor is moving backwards.

Unfortunately, moving or shuffling backwards appears to be a natural action when the play is coming towards you. The players need to be trained, taught and constantly reminded to hold position, stand still and not move back. You cannot launch forward or sideways into an intercept when moving backwards. It is only when the ball gets past them do they run back and position themselves in a space further back in the defensive third. I can't emphasise it enough - **Do not move backwards.**

STORY

At one time, I was coaching a team that loved and were very skilled at implementing the team zone. In one particular game the opposition team only managed to get through the zone once in the entire game and that was very near the end of the game. Admittedly there were some skill differences between the two teams. When the team eventually got through the zone, the team and all their supporters on the sidelines cheered and celebrated as if they had won a premiership. Their goal and focus had become finding a way to get through the zone. That's how effective a team defensive zone can be.

Skilled, fast opposition teams will get through. The zone isn't expected to turn over the ball every time. If the zone produces 5 or 6 turnovers in a game, that is a 5 or 6 goal advantage. As I pointed out, sometimes it will produce more. The challenge is to get every player back and in position quickly, not shuffling or moving backwards. The best way to get through a zone like this is to move the ball quickly before the zone can be set.

The zone is even **more intimidating** if all the players forming the zone raise their hands high in the air. An opposition team who has possession of the ball in the defensive third look up and see this wall of players standing like an army guarding a fort. The zone is not effective if one player is not doing their part.

Getting in position for individual intercepting

The trick in making a successful intercept is getting back quickly, taking position in the space ahead of the ball and get set to launch. An interception is made against the flow of the game. To make an intercept the player needs to be back far enough to have the time and space to set themselves to come against the play. When setting up for an intercept the defender does not chase the opposition player, instead, they run back and occupy a space. The interception skills have all been covered in drills 7.1 – 7.6.

I'm a believer that Netball Clubs should include an award each season for **The Best Defender**. This is awarded to the player who has made the most intercepts in a season.

CHAPTER 9

Skill Development - Drills 9.1-9.5
Team Strategies and Set Plays

There are many and varied team strategies and set plays that can be used in a game of Netball. I am only going to include a few basic ones to get things going. Once you have grasped these you can adapt them, change or extend them to suit your team or your coaching creativity.

General play team plan

Picture the game of Netball as being a business. Imagine it being a business that is divided into three sections

- the defense section – the defensive third
- the centre section – the centre third
- the attack section – the goal third.

Each section has their own manager. The manager is the go-to person when you first enter that section. Each section has an assistant manager who steps in when the manager is not available. Each section has a third in command for those times when both the manager and the assistant manager are not available. When every player in the team knows the structure and their role, they will know who to look for and who to pass the ball to when passing into each section.

- The **GD** is the go-to person in the defensive third.
- The **WA** is the go-to person in the centre third.
- The **GS** is the go-to person in the goal third, for general play only.

The GS is not the go-to person from a centre pass set play, as the GS sets up for space in the goal circle. This may be the case for other set plays as well.

A business needs to run economically and efficiently. Don't engage seven people to do a job that four or five people could do. In a game of Netball, the ball only needs to be handled once in every third. In moving the ball from one end of the court to the other, the most efficient manner is to use only three or four passes. Handling the ball less minimises the chances of mistakes. It moves the ball quickly, directly and more efficiently.

Example of this general play plan:

- From a base line throw-in, the GK passes the ball to the GD in the defensive third.

- The GD passes the ball to the WA in the centre third.

- The WA passes the ball to the GS in the attacking third.

- The GS passes the ball to the GA who shoots the goal.

Drill 9.1: Set play 1 - end to end in 4 passes

Drill without defenders:

- The whole court is required for this drill.
- This drill requires 5 players, GK, GD, WA, GS, GA.
- The GK starts with the ball and takes a throw-in from the base line.
- The GD starts on the defending transverse line in the middle of the court (reset or starting position).
- The WA starts on the attacking transverse line in the middle of the court (reset or starting position).
- The GA starts near the WA, both on the same side of the court so they do not take the goaler's space needed to run in to.
- The GS starts at top of goal circle (see figure 9a).

The play:

- The GK passes to the GD (pass 1).
- The GD runs forward and takes the pass in the defensive third.
- The GD passes to the WA in the centre third (pass 2).
- The WA runs forwards and takes the pass in the centre third.
- The WA passes to the GS.
- The GS runs out and takes the pass in the goal third (pass 3).
- The GA runs into the circle to the GPP and receives the pass from the GS (pass 4).

Team Strategies and Set Plays

End to end in four passes

figure 9a

Diagram labels:
- **WD** moves out of the way and draws the opposition WA away with them
- **C** moves out of the way and draws the opposition C away with them, or may apply a block on the opposition GA to allow the GD to get out easily
- **GA** starts here drives into goal
- WA starts here and drives across court into space
- GS starts here drives out
- GD starts here and drives forward
- GK, Pass 1, Pass 2, Pass 3, Pass 4
- Ball path / Running path

Drill 9.1 with defenders:

Once this running pattern is established a C, WD, and an **opposition C, GA, WA, GD, GK** are added to the drill.

- The C draws the opposition C away out of the space in the defensive third. Once the GK has made the first pass the C drives forward ahead of the ball and puts a block (zone) on the opposition GD allowing the GA to run into the goal circle. The C does not touch the ball but is important in making the play work.

- The WD blocks (zones) the opposition GA allowing the GD to get out for the first pass, or they take the opposition WA to the other side of the court to create the space. The WD does not touch the ball in this play but contributes by blocking or creating space to make the play work. Experiment with both options.

- The opposition GA defends the GD.

- The opposition GK stands behind the goaler and follows the goaler out of the goal circle.

- Players should wear position bibs to identify their roles.

Every player has a role so run the play slowly until it is understood.

Drill 9.2: Set play 2 - end to end in 4 passes starting with a lob pass

Drill without defenders:
- The whole court is required for this drill.
- This drill requires 5 players, GK, GD, WA, GS, GA.
- This is the same drill as in 9a only it starts with a lob pass to the GD.
- The GD sets up with space behind to take a lob pass (drill 3.7).
- The WA starts on the attacking transverse line in the middle of the court (reset or starting position).
- The GA starts near the WA, both to the same side so they do not take the GS space needed to drive in to.
- The GS starts at the top of the goal circle.

Starting positions

figure 9b

Ball path
Running path

The play

- The GK makes a lob pass from the base line to the GD who has set up with space behind (drill 3.7) (pass 1).
- The GD takes the lob pass and passes to the WA (pass 2).
- The WA runs forwards and takes the pass in the centre third.
- The WA passes to the GS (pass 3).
- The GS runs out and takes the pass in the goal third.
- The GA runs into the circle to the GPP and receives the pass from the GS (pass 4).

Drill 9.2 with defenders:

Once this running pattern is established a C, WD, and an **opposition GA, C, WA, GD, and GK** are added to the drill figure 9b

- The C and WD draw the opposition C and WA away out of the space to the other side of the court.
- The opposition WA and C follow their direct opponents.
- The GD takes position behind the opposition GA to take a lob pass from the GK (pass 1).
- The opposition GK starts behind the GS and follows the GS out of the circle.
- Once the GK has made the lob pass, the C drives forward ahead of the ball and puts a block (zone) on the opposition GD allowing the GA to run into the goal circle.
- The WA drives forward to receive a pass from the GD in the centre third (pass 2).
- The GS drives forward to receive pass 3 from the WA in the goal third (pass 3).

- The GA drives in to the goal circle to the GPP to receive pass from the GS (pass 4).

- The WD follows up behind the ball in case they are needed for a pass back.

Area management

The area management plan forms the basis for all general play. It is a basic team strategy. The GD, WA and the GS are the go-to person in general play situations. These players need to know they are the first option and position themselves well and be ready to make the play. If a turnover is made in the defensive third by a defender, this defender immediately looks for the WA in the centre third. The WA immediately looks for the GS in the attacking third. The GS comes out and the GA runs in. This applies to throw-ins as well but may be different for set plays. The other players need to assist the managers by not getting in their space. The other players may block the opposition so the managers can get clear.

The WD is the second option in the defensive third. The GA is the second option in the centre third. The GA is also the second option in the goal third. These are the go-to people when the first option is not available. When the first option is blocked, can't make position, or for whatever reason does not make the play, the second option is to be aware and make the play. They do not compete to be the first option.

The C is the third option. The C plays as a support person through all the sections. The C is the third option in the defensive and the centre thirds. Depending on what is happening on the court at the time, the C may become the third option in the attacking third as well. A smart C is needed to make the link when the other options are unavailable. The C needs to cover a lot of ground in both attack and defense.

If not used as a pass option, the C starts behind the ball (defensive side) and sprints to one of the corners (pockets) to be available as a feeder. We often see C players taking 5 or more passes down the court. This is not to be encouraged as they take up the space the other players need to keep the ball moving quickly. All players need to play their role. The only time this structure is abandoned is when the team is in a brief moment of 'free play' while the team structure is being re-established (see chapter 10 free play and improvisation).

The WA covers the opposite corner (pocket) to the C to be available for a feed if required. It doesn't matter what side each player takes provided

they take opposite sides. If the C has taken position first then the WA takes the other side or vice versa.

When the C player is used as a backup pass option, they start with the ball, pass and sprint forward to one of the corners to be available as a feeder. They need to be careful not to take the first option's space when they run forward. The WA does the same. The GD and WD stay behind the ball ready to receive a pass backwards (4th option) if all other options are covered. The GK stays back near the top of the goal circle to cover an opposition pass into their goal third, should the opposition gain a quick turnover. This is the set-up position for the GK to make an intercept should the ball be passed to the sides (drill 7.6). In this position the GK can also function as an extra back up pass option if all the options forward are blocked.

Taking space

When the ball is in the attacking goal third the GD and WD stand in the centre third in the team zone position (drill 8.1), one each side of the court filling the space in the event that the opposition get a turn over. They stand back far enough to make a play for an intercept if the opportunity presents. The positions of the WD and GD (see figure 9c) are defensive, but the players may move forward to the line to be a backward pass option if needed. It is not possible to cover every possible scenario and it will become over-complicated if I attempt to do so. It all comes down to the players' decision making at the time. The players have to decide what will be the best place to position. Attack - up to the line, or defense - back in the space.

When the ball is in attack the defensive positions behind the ball are taken in case of a turn over. These are the best positions for an intercept, and take space away from the opposition

figure 9c

Team Strategies and Set Plays

Keep things as simple as possible. Keep the free runners behind the ball so you do not crowd the attacking third. **More space in attack, less space in defense.** When the GS comes out of the goal circle and takes possession of the ball in the attacking goal third the GA, WA and C sprint to their positions. The GA drives to the GPP under the ring. The C and WA drive to the corners or to space for the next pass if the GS cannot pass the ball to the GA (see figure 9d).

In many cases the defending GK will follow the GS out of the goal circle leaving space behind for the GA to drive into. If the GK stays back and occupies the space the GA is driving to, the GS uses the corners or the GA makes a drive, in front of the GK. There are many options.

figure 9d

Drill 9.3: Set play 3 - centre pass 1 - 3 passes to goal

- This drill requires half of the court.
- 4 players are required for this drill C, WA, GA, GS.
- The C starts with the ball in the centre circle.
- The GA and WA start on the transverse line in their normal starting positions.
- The GS sets up for a lob pass in the goal circle protecting the space behind (drill 3.5 and 3.6).
- The C passes to WA in the centre third.
- The GA drives diagonally across the court into the corner on the same side as the WA.
- The WA passes to GA in the corner (drill 3.9).
- The GA uses a lob pass into the goal circle to the space behind the GS who is holding the defender under the ball with their body (drill 3.6).
- The GS shoots the goal.

figure 9e

Team Strategies and Set Plays

This play is simple but effective and has produced many quick goals. Its effectiveness depends largely on the players' ability to see and use space, as well as their skill levels to pass and catch the ball well.

Variation. GA and WA switch roles

- The GS sets up for a lob pass in the goal circle (drill 3.5).
- The C passes to GA in the centre third.
- The WA drives diagonally across the court into the corner.
- The GA passes to WA in the corner (drill 3.9).
- The WA uses a lob pass into the goal circle to the space behind the GS (drill 3.6).
- The players swap sides. This is for variety. The GA and WA start from the opposite side of the court.
- Add an opposition GK to stand in front of the GS.

Centre pass set play 1 in 3 passes – reversed

C passes to. GA. WA cuts across court to the corner to receive pass from GA WA uses a loop pass to the space behind the GS

Pass 1

Pass 2

GA

Pass 3

GS

GS stays put and holds

WA

C

C runs to the corner on the opposite side ready for a feed out if needed

Running path
Ball path

figure 9f

Drill 9.4: Set play 4 - centre pass 2 - backwards pass to goal three passes to score

- The full court is required for this drill.
- 7 players are required.
- Position the players according to the diagram positions (figure 9g).
- This is a 7-person set play however only 4 touch the ball.
- The GS sets up in the goal circle taking the front position to drive forward into space.
- The space is created by the GA and the WA who position themselves in the corner of the goal third on the left side of the court (refer figure 9g). The space is to the other side of the court
- The GA takes up position in the corner. The opposition GD will stand beside or behind the GA to defend.

GA runs off court and drives for the ring

This play is only done after a team goal.

The C enters the circle facing backwards.
C to GD to GS who drives from the goal circle.
WA stands behind opp.GD & WD and blocks them from following the GA

GA
GD
WD WA

GS drives out hopefully drawing the GK with them

WD
GA GK
Pass 1
C
Pass 2
GS
Pass 3

GD

GK & WD block opp. GA so GD can get out for centre pass

figure 9g

Ball path ⟶
Running path ⟶

- The WA stands behind the opposition GD to block them from running back towards the goal circle.

- The GA starts in the corner on the transverse line.

- The WA stands behind the opposition GD and WD blocking them from running back to the goal circle (zoning drill 6.1).

- The WA only needs to delay the opposition GD for 2 seconds for this play to work.

- The C steps into the centre circle facing the defensive end.

- The C times stepping into the centre circle, watching the GD, ensuring the GD is set and in position to make the play. I suggest the GD starts from a little behind the transverse line to get a run.

- As soon as the whistle is blown the GD makes their run into the centre third.

- The GK and WD assist the GD to get out by blocking the opposition GA.

- The C makes the pass to the GD.

- The GS positions in front of the opposition GK.

- The GS drives out of the goal circle into the space in front to take the pass from the GD.

- The GA runs off the court and doubles back driving towards the Goaler's Preferred Position (GPP) in the goal circle. The GD cannot follow because they are being blocked by the WA.

- The GS passes to the GA standing under the ring.

- The GA shoots the goal.

This is a very exciting and fun play. This play has the potential to confuse everyone, even the spectators. For a start the C enters the centre circle facing the wrong direction. Everything happens so quickly that it is hard to take in. This play is used after your team has scored a goal and has the next centre pass. (Possible 2 goals in under 10 seconds). The play sounds a bit complicated at first but in reality, it is very simple and only involves three passes. The success of the play depends largely on the players in the team that don't touch the ball.

- The WA blocking the opposition GD.

- The WD and the GK blocking the opposition GA, allowing the GD to get out for the centre pass.

- There needs to be a call from the Captain so the players know to get in position quickly. Example, after a goal has been scored the Captain or C calls "SET". This is the cue for the whole team to set up for the set play.

- All the players quickly run to the starting positions.

- The C watches and times their return to the centre circle. This set up doesn't take any longer that a normal centre pass set up. Success is all in the timing.

- Run the play first without defenders, three passes.

- Ensure the C player runs to the corner on the opposite side to where the ball has been passed.

- Add opposition players and include the blocks.

It is fun to set the team a challenge to beat their best time in scoring two goals in a row. C players should never step into the centre circle until ready to make a pass. The umpires are trained to blow the whistle for play as soon as the C steps into the circle. Timing is always important. The C looks around to see that the players are in position before stepping into the circle for all plays. Players need to be quick to get into their positions as the umpire can warn or penalise the C for wasting time.

In this set play, it appears to everyone watching that the GA and WA are trapped in the corner and have put themselves in a poor position. Every player on the team has a role to play (teamwork). This play only takes a

few seconds and the ball is in the hands of the GA standing under the goal ring, alone. Often, spectators are scratching their heads wondering what just happened and how did the GA get there, all alone. This play will only work if the defending GK follows the GS out of the ring, which they often do. It is a surprise play and should be used that way. Of course, if your team can make it work then why not keep using it. However, If you use it too often the opposition will work it out.

If the GK stays back in the circle and doesn't follow the GS out, the GS will need to pass the ball to the C who has taken position on the side of the circle. The GK will have two people to defend, the GA and the C. The GS will need to choose the best option.

Drill 9.5: The centre pass – getting out

Getting a centre pass off successfully is very important in a game of Netball.

- The full court is required for this drill. However, this drill is mainly played in the centre third.

- There is no limit to the number of players that can be used.

- This drill is done using groups of 3. 1 thrower (C) 1 attacker (WA) and 1 defender (WD).

- The ball starts with the thrower (C) in the centre circle.

- The attacker and the defender start in the goal third on the transverse line.

- On a whistle the attacker and the defender run into the centre third as if running out for a centre pass.

- The objective is for the attacker to get into the centre third first or at least get to a space where they are clear to receive the pass.

- The C passes the ball to the attacker (WA).

- Teach the attacker to identify the best places to run.

- The defender defends the attacker as they would at a centre pass in a real game of Netball.

- The next group of 3 come forward and do the same thing.

- The players change roles.

Variations

1. The attacker starts on the transverse line, positions themself on the inside of the defender using their body to protect space. The C passes the ball to the attacker's advantage (space).

2. The attacker starts on the transverse line, positions themself on the outside of the defender using their body to protect space. The C passes the ball to the attacker's advantage (space). The inside position provides the best advantage, but cannot always be taken.

3. The attackers choose to start from different positions across the attacking transverse line.

4. The attacker starts a few metres back from the transverse line to get a running start. The defender can start anywhere they choose.

5. The attacker baulks and dodges to get past the defender and into the centre third first. When they are clear they take the pass.

6. Add an attacking GD who starts from the defensive transverse line. The GD only comes into play when the WA has not managed to get clear. This aids the players learning regarding having a back-up option. In this case the C passes to the GD.

7. Include an attacking GA to place a block on the defender to make it easier for the WA to get out.

Centre pass - game simulation

- The full court is required for this drill. However, this drill is mainly played in the centre third.

- 9 players are required - attacking C, WA, GA, WD, GD – defending WA, GD, WD, GA.

- The players set up in the normal starting positions for a centre pass.

- The C starts with the ball in the centre circle.

- On a whistle the play starts.

➔ The C follows the team plan of options:
 1. The first option is the WA.
 2. The second option is the GA.
 3. The third option is the WD.
 4. The fourth option is the GD.

Practice this so the players get to know the options. Rotate the players through all the positions. This plan will not always work out, and in reality, needs to be varied. The WA, as the centre third option, may nominate the GA to make the play. The WD and the GD should be the backup options unless a set play is being implemented.

From a centre pass, the GS is not the go-to person in the goal third. The GS stays back in the circle setting up for a lob pass unless using a set play like the one described above (drill 9.4).

Italics = Defence **Bold = Attack**

figure 9h

This is only a small sample of drills around improving the centre pass. There are many more variations, additions and evasion drills that can be used. Practicing the centre pass is often neglected in training sessions for reasons I don't understand. If you have fast players with good evasive skills, it makes sense to make use of them and, if they happen to be your GA, then your GA becomes your first option. These drills are only a starting point and are not set in concrete. This book is not the Bible for Netball. This book contains drills that I have found helpful in training and teaching Netball.

CHAPTER 10

Skill Development - Drill 10.1

Free Play and Improvisation

It is not possible to script set plays for every situation in a game of Netball. There are many times in a game where free play, or improvisation, is required. If a turnover is made in a centre court zone, the first option in passing forward is to the GS in the goal third. However, the GS is still in the defensive zone position. The second option is also still in the zone position. In these situations, the team has to improvise or free play in order to keep possession of the ball until order and structure is restored. This is not an unknown game, as a lot of Netball is played in free play improvisation mode for the entire game.

figure 10a

In free play situations, the C steps in to restore order. The C gets on the move and runs to space and organises a short game of keepings off. The ball is passed around in an unstructured manner for a short time while structure and order are restored. The C takes control and directs play. The game of keepings off is best played in the defensive third if possible. This allows for space to be created in front of the ball. The objective is not to move the ball down the court, it is to slow the play down and provide the time for the GA, WA and GS to return to their starting positions.

Starting or default positions. All players know their starting positions in a game. These are the positions they take when the game begins.

Players should think of their starting position as being the default or the reset position. When a game is in free play, players should strategically return to their starting positions. Of course, the game doesn't stop to allow for this. The starting or reset positions allow for space and structure to be restored.

For example, the C has possession of the ball and is deliberately slowing things down in the defensive end of the court. The WA and GA are not in position to be the go-to person as in the general play system. The back up people are also not available as a backup. The game enters a state of free play or improvisation.

The structure of free play:

- The C takes control of the situation and organises a little game of keepings off with the GK, GD, WD.

- The players run around and pass the ball back and forwards long enough for the WA, GA and GS to return and reset to their default or starting positions.

From the default positions the WA can return to being the go-to person in the centre third and GS can return to be the go-to person in the goal third. By moving back to the starting positions, the GA, WA and GS generally draw their opponents back out of the play area which allows the defenders more space in which to play their game of keepings off. If you desire, the GA can get involved in the game of keepings off but must stay on the defensive transverse line and not move around too much. Remember, in attack space is your friend. Slowing the play down and playing short games of keepings off is a good option.

Drill 10.1 Free play – keepings off

- One third of the court is used for this drill.
- Six or eight players are required. 2 teams of 4, or 2 teams of 3.
- A game of four-on-four or three-on-three keepings off is played using Netball rules.
- Have one team wear bibs so the teams are clearly identified.
- Any player can start with the ball.
- The team with the ball pass it around between them trying to keep it away from the opposition.
- The players keep moving constantly.
- The team without the ball try to get it. If they take possession of the ball, they take over control of the game.

Variations

1. Play a game of 4 on 2.
2. Play a game of 4 on 3.
3. Play a game of 4 on 4.

When the numbers are uneven the team with the more players has the advantage. This often occurs when engaging in free play in a game of Netball. These are fun drills that teach the players how to engage in free play or improvised Netball. This drill helps develop avoidance and baulking skills and encourages the players to keep on the move. It also aids with footwork and passing skills.

Default – reset and return to starting positions

I recommend that all players reset to the starting positions whenever play stops for an attacking throw-in. Most of the drills featured in this book commence from these positions. For attacking throw-ins, starting back in the starting positions provides more space and structure to move the ball forward.

For opposition throw-ins from the sideline, moving players back to occupy space in the defensive end is a good option. The GA and WA come down to the defensive transverse line and the other players fill the spaces behind them (see figure 10b).

figure 10b

Once the ball has passed the WA and GA they move back to their starting positions. From the starting positions, the team has the space in front to run into should there be a turnover. This is a team defensive structure in which the space is defended and not the player. With this setup every player can see the ball coming and set for intercepts. It is not as strong a zone as the centre court zone because the opposition can pass more easily into the centre third and then directly into the goal third.

When defending, experiment with allowing the opposition the freedom to pass the ball around in the defensive end of the court unchallenged. Only the GS needs to get involved should the opposition pass the ball

back into the defensive third. The other players wait patiently in the zone position for the ball to come to them. **Do not walk or shuffle backwards.**

If the opposition has a throw-in from their defensive third, the centre court press or team zone is recommended (drill 8.1).

If the opposition team has a throw-in from the centre third or the goal third then this defensive third zone is recommended (see figure 10b).

If an intercept is made the team will need to move into a short period of free play or improvisation, a short game of keepings off. During this time the WA, GA and GS reset to starting positions. The WA, being the manager of the centre court, reads the play and when appropriate, restores things back to structured Netball by leading into the space created in the centre third. If for some reason the WA is blocked or can't get out, GA takes charge in the centre third and makes the play.

The general play system has the WA driving into the centre third to take the pass. The GS leads out into space to receive the pass from the centre third. The GA runs towards the GPP to take the pass from the GS (drill 9.1).

Rationale for the keepings off drill

This drill assists the players to improvise in a game of Netball. It teaches the players to move, position and further develop their catching, passing, driving, evasive and footwork skills. Keepings off requires the players to keep moving, something that is often neglected in a game situation. If the opposition is not defending hard, slow the play down to conserve energy. Sometimes you might have a four against three keepings off game which makes things a lot easier.

Free play does not continue for long periods in a game. Free play does not continue on down the court.

Running into a pass

Running into a pass is always a better option that running away from it. Standing still to receive a pass should be avoided as it provides intercept opportunities to the opposition. I have observed teams in which all players run down the court away from the player with the ball. When this happens, the player with the ball has very few options to go forward. This is a situation when the GD, GK or WD stay behind the ball and become a back pass option. This is free play or improvisation.

The C player initiates and controls free play

The section managers need to run back to the reset position to create space, then they turn to run back into that space towards the thrower where possible.

Once structure has been re-established, the centre court manager (WA) takes control back and the general play system is back in operation.

CHAPTER 11

Observing the Opposition

Local sports competitions are not like professional sports where you have access to replays and videos. However, there is great value in observing how your opposition plays. In most competitions you will get to play each opposition team twice or more during a season. This provides some opportunity to watch and see how they play. You may even invest an extra hour or so to watch your opposition playing in other games. A lot of competitions play a number of games at the same venue on the same day or night, so arriving a little earlier or staying a little later might prove to be a great use of your time.

Knowing how the opposition plays, knowing their strengths and weaknesses will assist you to plan and know what to train for. Often there are teams of roughly equal ability in a competition where a little planning and some specific training may provide you with the advantage you seek.

I started observing my opposition teams many years ago when I coached one of three teams that were very evenly matched in skills. Throughout the season my team managed to stay with both teams and provided a good contest but we never managed to win. The first of these opposition teams had a very skillful GA who controlled the court and was a really sharp goaler. She would shoot with around 95% accuracy from anywhere. This player was confident, smooth, fast and a Coach's dream. From my observations I identified two main weaknesses in this team and planned a way to use them to our advantage. The GA, even though very skillful, was rather short in stature. This at first didn't appear to be of any consequence as she rarely missed a shot. On the other hand, the opposition GS rarely attempted to shoot a goal, she would pass the ball off to the GA who was obviously the main scorer. Around 95% of the opposition team's goals were shot by the GA. The opposition GA was an excellent mover and very good at evasion when one-on-one. Both my defenders were taller than both the opposition GS and GA. We trained at improving our rebounding skills (drill 6.4 and 6.5). The plan included putting extra pressure on the

GA by double teaming and making her work much harder up and down the court (zone the player drill 6.1 & double-teaming drill 6.2).

The other part of the plan was to force the GS to attempt more shots. When the GS did take a shot, she had a success rate of under 50% (it may have even been lower). So, the plan was to leave the GS free and unmarked, double team the GA and force the GS to take the shot to create rebound opportunities and turnovers. When we met this team in the finals at the end of that season, we put the plan into action. The GS was surprised and put off by not being defended. The GA was being double teamed and there were no easy passes getting into her. The GS was forced to shoot. As expected, this provided many rebound opportunities. We secured nearly all the rebounds and scored from most. The opposition GA continued to influence and control the game in the centre third, but was double teamed and zoned when entering the goal third. She had to work hard and was often held up for substantial lengths of time. It was a very comfortable win to us in the end.

It is fairly rare that there is only one good goaler in a team and this would never happen in a high-level competition. However, some goalers are better than others and forcing the weaker goaler to shoot can increase the chances of a miss and a rebound opportunity. I include this example to explain how, by simply observing the strengths and weaknesses of your opposition, it can produce positive outcomes.

- what are the opposition's strengths?
- what are the opposition's weaknesses?
- do the opposition use any systems or set plays?
- who are the opposition's main players?
- do the opposition defenders stay back in the circle or do they chase out?
- how does the opposition GS set up in the circle?
- do the opposition defend the ball, the player or the space?
- are the opposition team fit enough to run out a full game?

- is there one opposition goaler who scores the majority of the goals?

- do the opposition do the same thing all the time?

Considering these things

- what do you need to do to counteract the opposition's strengths?

- what do you need to do to expose any weaknesses identified in the opposition?

- is there a good way to defend the systems and set plays the opposition uses?

- do the opposition provide any clues that they are going to implement a system or set play?

- how can we slow the opposition main players down?

- do we need to adapt certain plays because the opposition defenders stay back in the circle?

- does the opposition GS need to be double teamed?

All your opposition teams will play the game differently. All your opposition teams will have their stronger or more skilled players. Some players can control a game. Know who this player is. Observing the opposition can also provide you with positive plays or ideas you may be able to take back to your own team.

Early in my coaching journey, the first time I coached an Association State Representative Team in a Netball Carnival in Sydney Australia, I loved watching the team that went on to win the carnival. They used a simple set play from a centre pass over and over again that worked just about every time. I wrote it down and taught it to my team back in Melbourne (drill 9.3 set play 3 - 3 passes to goal which includes the lob pass into the goal circle, refer drill 3.6).

By watching other teams play you may see moves and skills that really impress you. Some you may have never seen before. You may consider

developing some training drills for your own team that will introduce and teach these skills. You may see something happen that has you saying "I really like the way they did that", "I really like the way that player defends", "I really like the way that player thinks and how she delayed that pass to give the goaler time to get into position". Things you can take back and teach your own team.

Getting back to the other team that we had trouble beating, I was confronted with a very different challenge. Again, this opposition team had a very skillful, dominant, smart and very competitive player. She played as the C and controlled the attacking and defending plays all over the court. She rarely dropped a pass, made a bad pass or made a mistake of any kind. One of her great assets was clearly her competitive spirit. She would attack and defend full steam ahead. She gave it everything. The other members of her team appeared to be energised and motivated by her efforts. This player had a weakness that could have easily been overcome. It was her fitness and stamina. Often, she would play the C position for 3 quarters and go into a goaling position for the last quarter. Having also lost to this team twice during the season I observed this team and set about working out a plan to beat them. Somehow, we had to stop this player early in the game if we were to have a chance. I didn't have anyone on my team that could match her one-on-one in overall skills. She was quick and evasive enough to break a zone and break through our defense.

What I did have, was a player who was a fitness fanatic and a running machine. This player was also a skillful player, very quick and athletic who I usually played in GA. This player could run flat out for hours. For this game I started her in centre. The plan was for her to run and run and run. I instructed her not to stop or stand still for the entire first quarter. She was instructed to tap into her opponent's competitive spirit and make her run, run, run. The opposition C would naturally run hard in attack and chasing her closely made her run even harder. When we had possession of the ball my C was instructed to keep running. I remember telling her "don't stop, make her chase you, wear her down". This all came from my observing that she lacked fitness and stamina and found it hard to run out a full game. As skillful as she was, she somehow neglected her fitness. She was so confident in her own abilities and skills that she believed that she didn't need to be any fitter. With other lesser competitive sides this may have been the case for her. The first quarter was played at a massive pace and as usual was very even and close. I think we were a little behind.

Not long into the second quarter the opposition C was bending over with her hands on her knees gasping for air. This is where the game turned. In the second half of the game, we were able to return to our normal team structure. The opposition C was not able to see out the game. We used her competitive spirit and her lack of fitness against her. We won the premiership that season fairly comfortably.

There is much to be learnt by observing the opposition. As a Coach, watch and analyse what they do. Watch and analyse how they play. Identify their play makers, what they do well and any weaknesses that can be seen. Identify if there are any patterns in their passing. Does the WA always pass to the goaler? Are they avoiding passing to a certain player? If the opposition team doesn't have confidence giving the ball to a certain player there must be a reason. Consider leaving this player unmarked.

Doing this turns you into a strategic Coach, a flexible Coach, an experimental Coach and an exciting Coach. You may have to take a few risks along the way but it is always a part of the fun and your growth. Share your thoughts and your plans with your team. They also may have some observations and ideas that are useful. Not everything you try will work. Where possible stay with the basic strategies and structures. When challenged try something different.

CHAPTER 12

Game Day

Game day can be rather stressful for some Coaches. Our competitive natures, our drive to win, our efforts to get things right, our sense of nervousness about the game, these, coupled with not knowing if all the players will turn up on time and that parent who wants to talk to you after the game, can take a lot of fun and enjoyment out of the experience of coaching.

Game day can sometimes seem like a chore that we don't really want to do. We have talked a lot about the need for the players to enjoy themselves and have fun, but what about the Coach? What can a Coach do to manage the stress of game day and enjoy the experience?

There is no simple answer to this question. We are all different with different needs and personalities. However, the aim should be the same. We aim to relax, have fun, enjoy the experience, stay calm, be happy, peaceful and be a part of the team. The Coach should work on not getting angry, frustrated, worked up or aggressive.

A good Coach will get more out of their players by remaining calm, positive, encouraging, controlled, respectful and happy. I know this is easier said than done. However, as the players you are coaching are encouraged to improve their skills, so should you as their Coach.

Some players have responded well in the past to aggressive, challenging Coaches. These Coaches believe that by demeaning their players, appealing to their inner strength and courage, they will get more out of them. I am not one of these Coaches. Humiliating, bullying and screaming at players rarely gets what the Coach really desires. This approach does little to build a sense of belonging or confidence in a player's efforts and abilities. This does not mean that you can't appeal to your players' desire to win and inspire them to dig a little deeper. It does not mean you can't point out how your players may do things better. Sincere encouragement

and pointing to your players' strengths, results in better self-belief, effort and positive outcomes. "I know you can run better than that. You are one of the fastest on this team".

What sort of Coach do you want to be?

Stress can be both healthy and unhealthy. Stress can drive us to improve, be better and achieve more. This stress is rewarding. Negative stress on the other hand is debilitating, unhealthy, dangerous and destroying. Managing stress on game days can be approached the same way as managing stress in any situation in life.

Be Organised

Being organised and in control is a good place to start. Know your team's starting positions the day before the game. Have all your needed equipment packed and ready to go. Make sure that you have a scorer and/or umpire should the competition require you to provide one. Get to the game an hour before it starts. Have a warm-up activity planned. Get your players to the game also an hour before it starts. This gives you time to warm up and not stress about latecomers, etc.

Imagine the opposite to this. It doesn't take much for you to see the difference it makes to stress levels:

You know your players, but have not had the time to put them in their starting positions. You will do this when you get there and see who turns up. You are running a bit late and discover the positional bibs are not with the ball bag. Where are they? You are not even sure who you are playing this week. You know that you had to get something for someone, but you can't remember what it is? You get to the game 10 minutes before it starts and only half your team is there. Say no more.

Taking the time to be organised ahead of time could prevent considerable stress and save your coaching career. Organised people stress less. This also applies to training sessions. Know what you are going to do and what order you are going to do them. Know why you are doing planned drills. Know how much time you will need to spend on each drill. If you don't spend enough time, your team does not benefit from the drill. If you spend too much time, you run the risk of your players getting bored. Be organised.

Feeling nervous on game day

Some Coaches just feel nervous because it is a competition. They get nervous when they play and they get nervous when they coach. To deal with this requires a self-management plan and a changed or challenged mindset.

Set your goals

Your goals are to stay relaxed, calm and enjoy the game and the experience, win lose or draw without getting stressed. It is good to win but it's okay to lose. It's not the end of the world. After all it's only a game, which we are meant to play and enjoy. A game about fun and exercise that gets people out and doing. A game where many friendships and bonds are made.

All competitive sports need a winner and a loser. Winning is always a better feeling than losing but losing can teach us many valuable lessons. It's not only okay to lose, sometimes it is necessary.

When you start to feel nervous, identify what you are thinking of at the time and change it. Think of a happy place or thought. This can be a place you mentally return to whenever you need to. It is a peaceful, happy, comfortable place where you feel safe. It may be an enjoyable relaxing activity. I used to mentally return to my best cricket innings where I would drive the ball through the covers and be running up and down the pitch. Sometimes I return to a holiday on the beach feeling the warm water around my feet.

It is very difficult to think of two things at the same time. You simply replace one line of thought with another. You can deal with the game when you get there, provided that you are organised.

Breathe slowly and deeply, relax your muscles and breathe out your tension. Go online and find some relaxation, meditation type exercises and learn how to use them when you're not nervous or stressed in preparation for the times when you are. Spend 30 minutes a day learning how to relax and train your mind.

Feelings are strongly connected to your thoughts and beliefs. Change your thoughts and beliefs and you will change your feelings. Relaxed or nervous?

Negative thought/belief: We are going to lose. If we lose again, I am a failure. I can't deal with this. Negative thoughts result in stress, nervousness, anxiety and depression.

Positive reaction/challenged thought: I am not going to dwell on this. If we lose, we lose, it's all a part of the game. I will deal with this when and if it happens. I can manage this and this is how I am going to do it.

Dwelling on something is going over and over it again and again in your mind. Discipline your thinking. Think of something else. Go to your happy place. Think about your next birthday. Think of your last holiday. This is not a book on stress management but if you think you could benefit more, take the time to research Mindfulness, Relaxation, Meditation, CBT. Develop some self-talk. Tell yourself you are relaxed and in control. Tell yourself to stay calm. Tell yourself you can do this.

Breathing

Concentrate on deep, regular, comfortable breaths. I can't over emphasise the importance of breathing. Breathing slowly and deeply provides oxygen to the brain. When nervous or stressed the body goes into survival mode, breathing becomes quicker and shallow. Thinking and control becomes more difficult. Breathe, breathe, breathe.

These techniques are also helpful for the angry Coach, but I will add, never attempt to solve a problem when you are angry.

In summing up

- be organised, be organised, be organised
- make a list of things that need to be done before each game and training session
- challenge and change any negative thoughts you may have
- set goals for the type of Coach you want to be
- be nice and kind to yourself
- keep a diary and manage your training drills
- develop some positive self-talk
- aim to stay happy, calm and relaxed
- remind yourself why you are coaching
- remind yourself of the many who benefit from what you do.

Assisting the nervous player

Players as well as Coaches can experience nerves on game day. Nervousness is a mind thing. Nervousness can cause stress that results in fumbles, panic, tenseness and mistakes. Remember that stress can be positive as well as negative and may result in extra effort, extra strength and speed. Note that negative stress directs extra blood to the muscles and away from the brain. Therefore, decision making may be poor.

Much of what I have written above can be applied to assist the nervous player. Keeping your game day routine the same can help to alleviate some nerves. Encourage nervous players to relax and enjoy the game and not over-think things. Encourage them to enjoy the experience and just do their best.

For some players you might decide to talk to them about their nervousness and explore ways they can deal with it better. Encourage them to relax and breathe deeply and slowly. Breathing deeply supplies the needed oxygen to the brain and helps avoid panic. Often, once the game is underway, the nervousness subsides. Expect more nervousness in big games and finals. Time and experience also assist in overcoming nervousness.

Doing the same catching and passing drills in training promotes muscle memory and minimises the chances of game day mistakes. Muscle memory takes over.

Relax, enjoy, have fun, make the most of the experience.

Chapter 13

Frustrations in Coaching

Working with and assisting frustrating players

Coaching can be fun and an exciting experience but it also comes with challenges and frustrations. A part of coaching is knowing how to manage and deal with these frustrations. Coaches by nature are competitive and strive to win and get the best out of their players.

There are some players who cause more frustration than others.

Player 1

This is the player who

- is naturally gifted and skilled and they know it
- is well coordinated and has the potential to be really good
- can do just about anything if they tried
- things come easily to
- you might consider a natural, gifted sporting talent
- loves the game of Netball, but the game has to be played on their terms
- is obsessed about how they look and how others see them
- only likes to play one position and won't put in the effort if the Coach asks them to play another
- doesn't take direction or instruction well
- is difficult to approach and talk to
- knows more about the game than the Coach

- likes to be flashy in attack but rarely defends
- often appears lazy on the court
- generally displays poor body language on court
- often looks like they would rather be anywhere else than where they are
- plays well within their limits and rarely pushes beyond the comfort level
- rarely looks at you when you are speaking to them or the team
- on the occasions they do look at you, stares right through you as if you are nothing
- looks at you as if you do not know what you are talking about
- doesn't like training and puts in minimal effort
- sees their own abilities as better than everyone else
- rarely comes across as warm and friendly
- displays an attitude that indicates that life owes them something
- believes that everything is about them
- lets others know they should be playing in a higher level, and can never understand why they don't get picked
- constantly is critical of most others' abilities
- never assists in setting up or packing up at training or games
- gives the impression that they don't want to play
- won't pass to other players if they don't like them.

I'm sure a few names and faces have popped into your head. Is this player a Coach's delight, or greatest nightmare? Whatever they are, they can cause the Coach a lot of frustration and angst.

What can a Coach do to manage and encourage such a player?

Most of this type of player will be teenagers. The teenage years can be the most challenging for many young people. It is the time when

- they are moving from childhood into adulthood
- they are experiencing the most changes, physically, mentally and emotionally
- they are developing their own identity, working out who they are and where they fit in the world
- everything is about them
- they develop their own views and opinions about many things
- they test limits, break rules and many rebel
- most things seem unfair
- no one understands them
- they experiment and explore their own sense of power.

PERSONAL REFLECTION

Now I ask you a question about yourself. Why have you decided or agreed to coach Netball?

It may be

- that you have a real love of the game
- because you have children or friends who play Netball
- that you believe it is a way to serve in your local community
- that you think it is wise to be involved in activities with your children

- that you love working with young people
- that you have played Netball yourself and feel that you have untapped knowledge and skills that can be passed on
- that you have personally received much from the game and would like to give something back
- an outlet to satisfy your competitive nature
- because you have been asked to coach by someone who believes you have the knowledge, skills and temperament to coach
- because there is a need for a Coach and the team might not be able to continue playing if they can't find someone to coach them.

Netball
- is a sport and a social activity
- gives people an interest
- is a fun activity
- is a healthy activity
- gives many young people something to do
- provides physical activity and promotes fitness
- is an activity that develops skill and coordination
- provides opportunity to make friends and socialise
- is an activity that teaches people teamwork and how to work together
- teaches people about what it is to win and to lose
- teaches people the art of respect and sportsmanship
- is an investment that requires time

- can be an activity that keeps people off the streets and out of trouble

- can be an important outlet for some people.

Coaches sometimes get caught up and fixated on winning. The focus becomes all about winning. This might have a place in professional sport but it is not what social and community sport is about. The people you are coaching are always more important and valuable than any game result. These are real people, with different skill levels, from diverse backgrounds and family environments. They have different levels of interest, enthusiasm and different needs. Many parents insist that their children play some sort of sport.

I am a professional counsellor and I worked with teenagers for 40 years. Parents of teenagers have often asked me what they should do to be good parents or how they can best help their child. Often this has been after the child has landed themselves in some sort of trouble. There is no simple answer to this question but many times I have said "KEEP THEM BUSY". Idle hands usually find trouble. Get them involved in Scouts, swimming, calisthenics, dancing, the local volunteer fire brigade, music, sport etc. Netball is just one activity that can engage and occupy them for years.

This may require a great time commitment from the parents in running them around to training and games but it is a worthwhile investment. Watch them, get involved where possible, do things with them. Keep them busy and occupied. Show a sincere interest in what they are doing and encourage them even if they are not really good at it.

There could be players in your Netball team who are there at their parents' insistence. The parent may want their child involved more than the child themselves. In coaching you may be assisting a parent in helping their teenager through some difficult years. A Coach may take the attitude, if you won't do what I ask you, if you won't put in a reasonable effort, if you won't contribute as a team player, then I don't want you on the team.

Community sport is not professional. It is about fun and involvement. Young people need to be encouraged, guided and kept busy. Young people need to know that there are people around who care, understand and believe in them. A Netball Coach may be the person a teenager turns to when they feel that they can't talk to their parents.

The Coach can try to talk with such a player, encourage them, reason with them, even ask the player what they want from them and the club and receive absolutely nothing back.

Managing and dealing with a player of this nature

- treat them with respect
- treat them the same as you do all your players, no better and no worse
- avoid openly showing your frustrations when they don't comply
- focus your attention on the positives
- praise the things they do well but don't overdo it
- don't praise them any more or any less than you would praise the other players
- be patient with them
- encourage them
- keep your instruction in the positive frame
- tell them what is required, rather than not what to do
- avoid don'ts where possible. Use "try not to move forward too much" rather than "don't move forward too much".

You might attempt to give them some responsibility and run some drills. It might work, but it most likely won't. If they decline to lead a drill once, don't give up. Move on and ask them again next training session. They may have thought about it and changed their mind. Let them know that you care about them as a person. Let them know that you see them as being more important than someone who just fills a place on the team.

If you are doing a team drill and the frustrating player is the only player that won't run to get into position, praise the ones who have, without drawing direct attention to the only one who hasn't. Try to use peer or

group pressure to get them to cooperate. There is pressure to comply when the frustrating player is the odd one out, the only one not doing it. You might say to the whole team. "Okay that wasn't bad. This time when I blow the whistle, I am going to time you to see how long it takes everyone to get in position".

The frustrating player often considers themself better and superior to everyone else. They are competitive by nature and want everyone to know and see them as being the fastest and the best. Again, it may work but it probably won't. The Coach just needs to be patient and keep trying different things as you go.

If you are doing a 7-position drill and have more players than 7, rotate them all. See which combination completes the drill the fastest, the group that includes the frustrating player or the group that doesn't. Don't draw any attention to this, the player themself will pick up on it.

There needs to be a bit of a psychologist in every Coach. Don't try to talk to them about their attitude, you will be wasting your breath. Engage them in conversation casually about other things, music, fashion, school, other activities that they may be involved in, what they might be doing on their next holidays, etc.

Always be friendly and say hello. Don't get discouraged if you don't get a friendly response back. After sometime they might see that you are a sincere, nice and friendly person. If the frustrating player wants to talk with you and initiates a conversation, by all means give them the time. **Listen, listen, listen and listen some more.**

Avoid justifying your decisions and acknowledge the player's feelings. The player may want to talk to you about spending a quarter of the last game off the court. You may ask, "How did it make you feel when this happened?" Remember that the player who frustrates you the most, most likely considers themselves the best and most valuable player on the team. They most likely won't verbalise it, but they see themselves a far better player than the one who took their place. You might acknowledge their feeling and ask for advice rather than justifying your decision. "So, it upsets you when I give equal court time to everybody on the team. What do you suggest **we** do as a team?" Be careful not to share any personal information about other players.

I am getting a little too deep into Counselling techniques now and I don't expect Coaches to be experts in counselling and psychology. I hope that

I have provided a little insight and a few ideas that may prove helpful to some. Remember, all your players are more important than any game result.

You will have picked up by now that I am competitive and I like to win as much as the next person. We need to teach, train, encourage, extend and challenge our players in all areas of the game. However, the game is played by people, people who need to belong, people who want to have fun and enjoy the journey and the experience.

Winning is more fun than losing. **Life is more about the journey and what happens along the way** than the destination. People first. Fun, engagement, values, belonging, friendship and encouragement hopefully lead to success.

What is success?

Is it building a team of lifelong friends who have fun playing with each other?

Is it about encouragement that promotes development?

Is it about valuing each player and their contributions?

Is it about assisting young people to grow and develop into good people.

Or, is it just about winning?

Avoid going behind the player's back to the parents if it can be avoided. Some things can't be avoided.

Frustrating Player 2

This player is the very opposite to the first player I have described.

This is the player who

- tries very hard
- is really friendly and very keen to please
- is very helpful
- is the first to training and the last to leave

- helps with the equipment, setting and packing up

- gets on better with the adults than the other players in the team

- makes a point to smile at you, be friendly, say hello and goodbye

- finds it difficult to be accepted by the more popular and skilled players in the team

- is polite and well mannered.

- is not very talented and somewhat clumsy.

This is the player that the Coach doesn't know what position to play them in. If solely based on skill level they would never get picked to play. If based on likability and effort, they would be one of the first picked. This player's lack of skill and coordination has resulted in many lost games. They are proud to be involved in the team. It means a lot to this player to belong and to be included. This player loves the game and wants to improve and please.

Most, if not all of the things pointed out about Player 1 also applies to Player 2. This person is more valuable than any game result. Allowing them to be involved is assisting in their emotional, mental and physical development. These players need to be encouraged and valued. These players are aware, as everyone else is, that they are limited and not as skillful and talented as the others.

It is difficult to know what to do with this player. The competitive nature says, do not play them. Netball is a competitive sport and everyone wants to win. Everyone needs to be given equal opportunity. It probably means a lot to this player's parents that they have a place to belong and be involved. This player deserves to be treated the same as everyone else and should be given the same opportunities. Belonging, involvement and acceptance are what this player craves.

This player doesn't get much enjoyment out of dropping a pass, giving a poorly directed pass or turning the ball over because of their poor balance and coordination. Encouragement and finding tasks to assist the team in training and in matches can be of great benefit to this player

and the team. This player wants to help, please, be involved, belong, feel important and contribute in some way. If this can't happen on the court then we find ways to involve them off the court.

The player might

- be given the responsibility to get out, set up and move equipment around at training

- be given the responsibility to organise, distribute and collect the position bibs at the start and end of games

- be given the responsibility to distribute water and/or refreshments

- act as the Coach's assistant on game days

- be given responsibility in helping to score or keep statistics

- be asked to record the number of intercepts made in a game and who made them

- be given the responsibility to manage the balls, ensure they are inflated, available, collected and put away at the end of training

- be trusted with a key to the equipment shed.

There are a number of ways this player can contribute, belong and be valued in a Netball team.

Be patient with them. Talk to them about what they might like to do and how they can assist the team in important ways. They may even decide not to play and be involved in other ways. They might decide to play and take on these other responsibilities as well. They may never be the best player on the team but they can improve and feel valued. Who knows, with time they may develop into a more skillful player.

Dealing with Parents and Spectators

Many teams have sideline Coaches. Parents and spectators who know where each player should play and how much court time each player should get. Parents and spectators who know better than the Coach as

to how the game should be played. Many parents or spectators let their thoughts and opinions known via the grapevine and can stir up unneeded trouble. Some may be even more direct in expressing their thoughts and opinions. Parents and spectators can have a strong negative impact on the enthusiasm, effectiveness, health and wellbeing of the Coach.

Parents, as you would expect, have a bias. They want the best for their child and often see their child's abilities as better than they actually are. Parents can be defensive and protective. If a parent feels that something is not fair, they may go into battle on behalf of their child. Parents like to promote their child and push for them to play in certain positions. Some parents are very competitive and have a win at all cost mentality.

Coaches draw much pressure and criticism from parents and spectators
Accusations or criticism

- around favoring certain players over others
- for not playing the players in their correct positions
- for playing players in positions they are not suited for
- for not giving certain players enough court time
- for giving other players too much court time
- for taking a player off the court, replacing them with a less skillful player when the game is in the balance
- around not knowing enough about the game
- about not having the right temperament to coach
- about having favourites.

Parents and spectators can take the enjoyment out of the game for the Coach. Parents and spectators can put the Coach in a position that makes them feel they need to justify their decisions and actions and they may become defensive.

My advice is, do not listen, do not listen, do not listen to unjustified criticism. Leave the noise on the sidelines.

Do not justify or respond

Keep concentrating on what you are doing and don't get drawn in to political type arguments. No one wins. Everyone loses. There is a temptation for the Coach to justify actions, defend themself and a desire to put the negative person in their place. When I say no one wins, what I mean is, everyone involved becomes more upset. The Coach considers if it is worth the effort to continue to coach. The parent decides to take their child out and go play somewhere else. The player may lose friends and be embarrassed by the parents and the Coach's confrontation. No one wins.

The Coach does not listen and concentrates on their role, the training, the games and the skill development. The Coach continues to provide fun and learning for the team. The Coach continues on as if nothing has been said. It is not easy to block things out but with some discipline and effort it can be done. Remember parents have a bias and a vested interest to get what they believe is best for their child. Any good parent will fight to defend and aid their child along the way. It may not be the best way go about it, but I can understand it.

Do not listen, do not take anything to heart, do not ponder and go over and over what has been said in your mind. Ignore it and make the best of the times you have with your team.

In the times where the Coach cannot ignore the parents, when the parent has confronted the Coach, listen, listen, listen and listen some more. Try to understand where the parent is coming from even if you do not agree with them. Never justify your actions or your decisions. Many a potential argument or uncomfortable confrontation can be avoided if we just listen.

As I mentioned before, in my professional life I worked as a counselor with teenagers in schools. Many times, an angry, upset parent came into the school to fight for the rights of their child and defend them. The school would often engage me to meet with these parents. Many a parent was expecting a fight and was surprised when they didn't get one. Sometimes all the parent needs is someone to listen to them, to be heard and understood. Listening and making an effort to understand a point of view takes the sting out of many potentially nasty situations. Listen to understand. By listening you can find common ground. The common ground here is that you both want what is best for the player. You both have the player's best interest at heart.

Acknowledge any emotion expressed "I can see you feel strongly about this, please help me understand better". You don't need to agree or change anything you are doing. However, there may be something in what has been said that you can take on board and become a better Coach. Be polite, respectful and approachable. Stay calm, don't get drawn into an argument and then everyone can win. Don't go looking for these confrontations. Avoid them whenever you can. Accept that you will be criticised but try not to listen and take it in. Like water off a duck's back.

Conclusion

I have included enough information in this book to keep you engaged in coaching and teaching the skills of Netball for many years. The exercises and drills are not exhaustive but every element of the game has been covered in some way.

From passing, to passing to advantage, from attacking to defending, from individual skills to team plays, all have associated drills that assist learning and developing the skills required in playing the game of Netball.

Enjoy your coaching, have fun, fun, fun.

Ian Findley

Acknowledgements

I wish to thank my wife and life partner Julie for your wonderful support, patience and encouragement throughout this project. Your proof reading, the time you have invested in assisting me to complete this book has been gratefully valued and appreciated. A real act of love and teamwork.

Thank you to my daughter Nicole Psaila, my daughter Narelle Draper and my Granddaughter Zoe Draper for your input, contributions and work in getting this book to the point of completion.

Your knowledge and experience in Netball has been invaluable and added much to the production of this book.

Thank you to my neighbor Amy Lyttle for your assistance with the art work and diagrams. I have really appreciated your skill and willingness to assist when I needed it.

Thank you so much to all the wonderful, supportive and talented people at Busybird Publishing with special thanks to Kev Howlett and Les Zig for all you have done to assist me. You believed and supported me in this project from the beginning and your guidance and support over the journey has been greatly appreciated.

Finally, I thank all the Netball players that I have had the pleasure of coaching, teaching and training over the years. Your work, efforts and support have created the opportunities to develop, test and improve the plays, ideas, drills and strategies that I have shared in this book. I thank you all for what you have taught me about Netball and life.

Ian Findley

www.ifindbooks.com.au

As President and Founder of a local grassroots Netball Club, I have found it an interesting journey appointing and equipping people to coach. Many of those who volunteer their time are parents or ex-players, but have never had to break down the specifics of netball to teach it. This book gives great insight and many ideas for coaches to implement, regardless of their coaching style or journey. Within these pages coaches will find many different drills and ways to keep their players engaged and enjoying the sport of netball. Our players thoroughly enjoyed the drills in this book.

This book is a great gift or resource to give any coach, new or experienced.

Narelle Draper
Hazel Glen Netball Club President

"As a player, *A Complete Guide to Coaching and Teaching Netball* helped me think about my own game play and how I could use these drills to be a stronger player."

Maggie Turner
Netball player and umpire in the Southern Football Netball League